Looking at

MATISSE

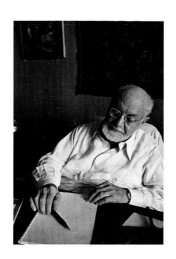

and

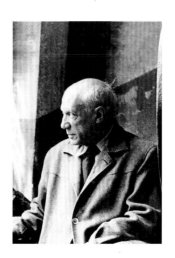

PICASSO

María del Carmen González
Susanna Harwood Rubin

The Museum of Modern Art, New York

Published in conjunction with the exhibition *Matisse Picasso*, at MoMA QNS, New York, from February 13 to May 19, 2003, organized by Elizabeth Cowling, John Golding, Anne Baldassari, Isabelle Monod-Fontaine, John Elderfield, and Kirk Varnedoe

The exhibition and its accompanying catalogue and education programs are sponsored by Merrill Lynch.
A major grant is also provided by The Starr Foundation.
An indemnity for the exhibition has been granted by the Federal Council on the Arts and the Humanities.
Additional funding is provided by Monique M. Schoen Warshaw.

This book is a project of the Department of Education of The Museum of Modern Art

Produced by the Department of Publications,
The Museum of Modern Art, New York

Edited by David Frankel
Designed by Gina Rossi
Production by Marc Sapir
Printed and bound by Snoeck Ducaju & Zoon N.V., Gent

This book is typeset in Filosofia. The paper is 150 gsm Gardamatt

Published by the Museum of Modern Art
11 West 53 Street
New York, New York 10019
(www.moma.org)

Library of Congress Control Number: 2002117235
ISBN: 0-87070-005-7

Printed in Belgium

Front cover, top to bottom: Henri Matisse. *Large Reclining Nude (The Pink Nude)*. 1935. See p. 62. Pablo Picasso. *Girl before a Mirror*. 1932. See p. 63. Henri Matisse. *The Piano Lesson*. 1916. See p. 46. Pablo Picasso. *Three Musicians*. 1921. See p. 47. Back cover, left to right: Pablo Picasso, c. 1915–16 (detail). See p. 4. Henri Matisse, probably 1909. See p. 9. Title page, left to right: Pablo Picasso, c. 1950–51. See p. 7. Henri Matisse in the Hotel Régina, Nice-Cimiez, 1948 or 1949. Photograph: Robert Capa/Magnum

Photograph Credits

Front cover: all The Museum of Modern Art, New York, except top: The Baltimore Museum of Art. Back cover, left: Réunion des Musées Nationaux/Art Resource, NY. Back cover, right: Archives of The Museum of Modern Art, New York. Title page, top: Robert Capa/Magnum Photos. Title page, bottom: Ministère de la Culture, France. Pp. 4, 14, 15, 18, 27, 34: Réunion des Musées Nationaux/Art Resource, NY. Pp. 5, 17, 19, 22, 29, 30, 35, 37–39, 43, 45–47, 49–51, 53, 57 right, 58, 61, 63, 65–67: The Museum of Modern Art, New York. P. 6, left: Robert Doisneau/Rapho. P. 6, right: Paris-Match. P. 7: Ministère de la Culture, France. P. 9: Archives of The Museum of Modern Art, New York. P. 10: The Philadelphia Museum of Art. Graydon Wood. P. 11: Statens Museum fur Kunst, Copenhagen. Hans Petersen. P. 13: David Douglas Duncan. Pp. 21, 31: The State Hermitage Museum, St. Petersburg. P. 23: The St Louis Art Museum. P. 25: CNAC/MNAM RMN. Philippe Migeat. P. 26: Beyeler Foundation, Riehen/Basel. P. 42: Columbus Museum of Art. P. 54: The Pushkin State Museum of Fine Arts, Moscow. P. 55: Tate Gallery, London/Art Resource, NY. P. 57, left: Cahiers d'art, Paris. P. 59: The Phillips Collection, Washington, D.C. P. 62: The Baltimore Museum of Art. P. 68: AKG, London/Camera Photo. P. 69: The Museum of Modern Art Photo Archive

Acknowledgments

The authors would like to thank Chief Curator at Large John Elderfield and the Edward John Noble Foundation Deputy Director for Education Deborah Schwartz for their help and support for this book. Thanks must also go, in the Department of Chief Curator at Large, to Sharon Dec; in the Department of Education, to Marine Putman, Jane Tschang, Risë Wilson, and the rest of the staff; and in the Department of Publications, to Michael Maegraith, David Frankel, Gina Rossi, and Marc Sapir

Introduction

It is an afternoon in Montparnasse, a neighborhood of artists and writers near the center of Paris. The restaurant and bar La Coupole, a popular local gathering place, is bustling with activity, including a group surrounding the artists Henri Matisse and Pablo Picasso. At some point Matisse leaves the group. When his absence is noticed, Picasso makes a flippant comment about him. Several people in the party start to make insulting remarks about Matisse, hoping to please Picasso by tapping into the competitive nature of the two artists' friendship. Angered, Picasso yells, "I refuse to let you say anything against Matisse. He is our greatest painter."

In this exchange we get a glimpse of the rivalry, the passion, and the complexity of the friendship between Matisse and Picasso.

Pablo Ruiz Picasso, born in Málaga, Spain, in 1881, was an artistic prodigy. When he was fourteen he began taking advanced classes at the Barcelona School of Fine Arts (where his father was a professor), after completing the month-long entrance exams in one day. Later he briefly attended the Royal Academy in Madrid, again completing the entrance exams in one day, but he soon dropped out, to his father's dismay. He then returned to Barcelona and found himself a studio where he could work independently. In October of 1900, around the time of his nineteenth birthday, Picasso left Barcelona for Paris. Although he briefly returned to Spain, this trip gave him his first taste of the Paris avant-garde, the artists in the forefront of creative innovation. Picasso was young, unknown, and barely spoke French, but he was completely intoxicated by the city's energy and excitement.

The Paris of those years was a hotbed of creative activity. Intellectuals mixed until dawn with the habitués of cafés, bars, and nightclubs; musicians, writers, and artists from all over Europe mingled with many other sorts of creative people, such as circus and cabaret performers. Young and often penniless, artists lived on the fringes of society, isolated from ordinary middle-class life. The unconventionality of their life-styles was reflected in their work: they were experimenting with new ways of making art, and challenging the public's ideas about what art should be.

Henri Émile-Benoît Matisse, born in Le Cateau-Cambrésis, in northern France, in 1869, was twelve years older than Picasso, and had been a working artist in Paris for several years by the time Picasso arrived there. As a young man he had studied to be a lawyer, but had abandoned this plan to go to Paris and study painting. Matisse's father, although unhappy with this decision, gave him an allowance that enabled him to pursue his new career. He studied under well-known artists and copied masterworks in the Louvre museum—common practices among art students of the time.

The Paris art world of the period was divided. In earlier years, the inclusion of an artist's work in a salon, a juried exhibition connected to the traditional art academy, had been a crucial measure of success. The salons were conservative and academic, and often rejected innovative work. As a result, the younger artists began to establish their own salons—the "Independents' Salon," which was unjuried, and the

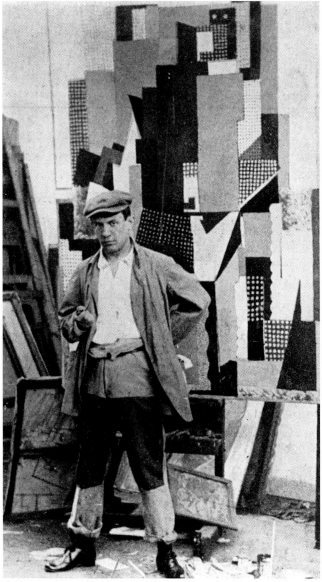

Pablo Picasso in his studio at 5 bis, rue Schoelcher, Paris, c. 1915–16. Private collection

"Autumn Salon," which was juried by its members. At the Autumn Salon of 1905, Matisse and a small group of other artists, including André Derain, exhibited paintings in a palette of bright, unnatural colors that shocked many viewers. Some critics found the works "crude" and "barbaric." One prominent Paris critic labeled these artists the "Fauves," or the "wild beasts," a name that stuck. Matisse, who was seen as the leader of the group, would soon be crowned the "King of the Fauves."

Around this time, Picasso began to frequent the dinners and parties hosted regularly by Gertrude and Leo Stein at their apartment on the rue de Fleurus, near Montparnasse. Gertrude Stein was an innovative writer and poet, her brother Leo was an art collector and critic, and the apartment these two Americans shared became a gathering place for the artistic avant-garde. They also collected art, supporting and nurturing the careers of many young artists.

The Steins had acquired works by both Matisse and Picasso before the two artists met. Although there are many accounts of how that meeting happened, one of the most likely possibilities is that the Steins set it up at their apartment sometime in 1905 or 1906. Later, Picasso and his girlfriend, Fernande Olivier, developed a routine of visiting Matisse and his wife on Friday evenings. Then, on Saturday evenings, all four would go to the Steins'.

When Matisse and Picasso first met, Olivier saw the differences between them. She described Matisse as "very much the master of himself at his meeting with Picasso, who was always a bit sullen and restrained at such encounters. Matisse shone imposingly." She also said of Matisse, "Whenever he began to talk about painting, he chose his words deliberately." Picasso, on the other hand, was not known for providing explanations of his work. He once said, "You mustn't always believe what I say. . . . Questions tempt you to tell lies, particularly when there is no answer." In addition to differing in personality, the two artists differed in their habits. Matisse kept an orderly studio and worked methodically; Picasso's studio was overflowing with objects and art, and he often worked through the night and slept until afternoon.

Matisse and Picasso had a complicated relationship: they inspired each other, pushed each other, ignored each other, and competed with each other even when they were out of contact. There were

moments of jealousy and rivalry. Some of this was fueled by shared acquaintances, who repeated and distorted remarks each had made about the other. Early on, their relationships with Gertrude and Leo Stein could sometimes be divisive: on occasion the Steins would acquire more artwork by one than by the other; sometimes they would question the artistic direction that one of them was taking. Despite these fluctuations, the Steins played pivotal roles early on in the artists' careers and friendship.

Matisse and Picasso sometimes mistrusted each other's artistic ideas and intentions. In 1946, in a letter to his son Pierre, Matisse wrote, "Picasso came to see me. . . . He saw what he wanted. . . . He will put it all to good use in time. Picasso is not straightforward. Everyone has known that for the last forty years." In an earlier letter to his daughter, Marguerite, Matisse had gone so far as to call Picasso "a bandit waiting in ambush." Picasso had complaints of his

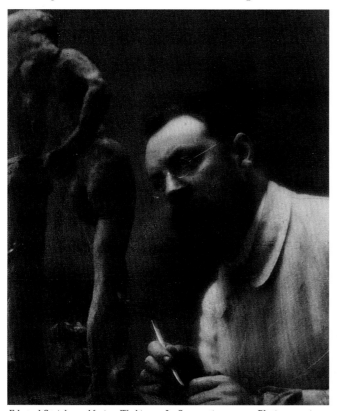

Edward Steichen. *Matisse Working on* La Serpentine. 1909. Platinum print, 11 11/16 x 9 1/4" (29.6 x 23.4 cm). The Museum of Modern Art, New York. Gift of the photographer

own about Matisse—yet ultimately both men recognized their need for their friendship. Tellingly, both artists are remembered as having said, "We must talk to each other as much as we can. When one of us dies, there will be some things the other will never be able to talk of with anyone else."

The two men also supported each other in a variety of ways. Early in Picasso's career, Matisse generously brought one of his own most important collectors to see the younger artist's work. Years later, in 1944, it was Picasso who made sure that artwork by Matisse was included in the Autumn Salon, which that year was called the "Liberation Salon," since it opened six weeks after the liberation of Paris from the German occupation during World War II. Picasso even lent a painting of Matisse's that he owned, *Still Life with Basket of Oranges* (1912), for the exhibition. Throughout their friendship, Matisse and Picasso regularly exchanged gifts and works of art. Toward the end of Matisse's life, when he was in poor health, he and Picasso wrote to each other regularly, and Picasso visited him often.

Despite their competition, Matisse and Picasso had an unshakable mutual admiration. Once when Picasso was asked if he liked Matisse's work, he responded, "Well, Matisse paints beautiful and elegant pictures. He is understanding." Matisse, when asked his opinion of Picasso, similarly replied, "He is capricious and unpredictable, but he understands things." In 1954, when Picasso heard of Matisse's death, he simply said, "*Au fond, il n'y a que Matisse*": "In the end, there is only Matisse."

The professional lives of Matisse and Picasso often ran parallel, and included several shared exhibitions. Early on, in 1902, both of them showed with the Paris art dealer Berthe Weill, and around the same period both also had exhibitions at the gallery of Ambroise Vollard. In 1918, a Matisse/Picasso exhibition opened at the Galerie Paul Guillaume, Paris. In the autumn of 1931, a retrospective

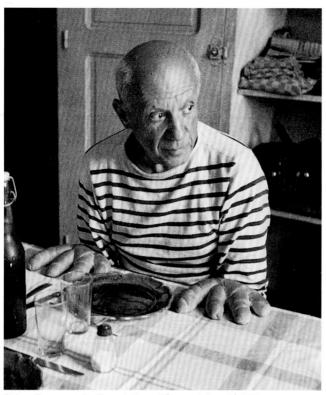

Robert Doisneau. *Les Pains de Picasso* (Picasso's breads). Vallauris, 1952

seem to have been having a conversation through their art—almost as if they were finishing each other's sentences. Matisse once told his friend Max Jacob, a poet who was also friendly with Picasso, "If I weren't doing what I'm doing, I'd like to paint like Picasso." "Well," said Jacob, "that's very funny! Do you know that Picasso made the same remark to me about you?"

Matisse and Picasso had a tremendous impact on the history of art and on each other. They inspired each other to experiment and innovate, pushing the boundaries of what was accepted as art. Works like Picasso's *Demoiselles d'Avignon* (1907) combined artistic styles within one painting. The invention of collage by Picasso and Georges Braque expanded concepts of how and from what art could be made. Matisse, in works like *Self-Portrait* (1906) and *Goldfish and Sculpture* (1912), changed notions of color in painting. His Backs and Jeannette series show the dramatic steps he took toward abstraction. His late paper cutouts, so iconic that he called them "signs," introduced a new way of merging color with the purity of drawing.

exhibition of Matisse's work opened at The Museum of Modern Art, New York; Picasso had a retrospective there in 1940. In 1938, Matisse and Picasso shared a two-person exhibition in the Boston Museum of Modern Art. The Autumn, "Liberation" Salon of 1944 honored Picasso with a one-person show; Matisse had a one-person show in the Autumn Salon of 1945. At the end of that year, the two artists had simultaneous one-person exhibitions in the Victoria and Albert Museum, London.

To grasp the complexity of Matisse's and Picasso's artistic relationship, we must look at their works next to each other. The selection of images in *Looking at Matisse and Picasso* highlights moments when the two men were looking at, learning from, and responding to each other's art. Some of the works that are paired here were made at very different times, but are connected by common themes or techniques; others show quite specific connections. There are even cases where Matisse and Picasso

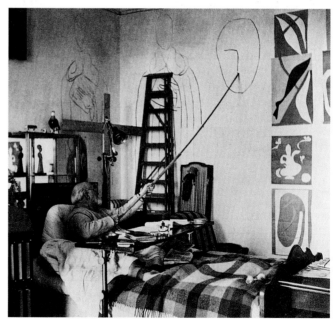

Matisse using a bamboo pole to draw while bedridden in the Hôtel Régina, Nice-Cimiez, 1950. Photograph: Walter Carone, Paris-Match

These two great pioneers in art approached art-making in various ways over the course of their lives. Early in Matisse's career, his boldly colored work was seen as "naïve" and "unfinished." He believed, though, that "you begin painting well when your hand escapes your head." Picasso similarly argued, "A painting is not thought out and fixed beforehand; while one is painting it, it follows the mobility of one's thoughts." He also described painting as a type of compulsion, saying, "I paint the way someone bites his fingernails; for me, painting is a bad habit because I neither know nor can do anything else." Matisse and Picasso continually observed and judged each other's work. Picasso once said to Matisse, "I've mastered drawing and am looking for color; you've mastered color and are looking for drawing." Matisse made a comparison of his own when he said, "Picasso shatters forms . . . I am their servant."

For many years, Matisse and Picasso together defined what the forefront of modern art meant. Their creative curiosity and determination propelled them forward. Late in his life, Picasso said, "For myself, I wanted to prove that success can be obtained without compromise, even in opposition to all prevailing doctrines." Matisse, also looking back on his life as an artist, stated, "One must always guard one's freshness, in looking and in emotion; one must follow one's instinct."

Finally, woven into the complex friendship between Matisse and Picasso was a constant ex-

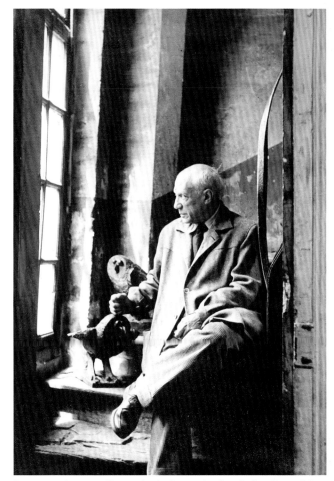

Picasso on the steps of his studio on the rue des Grands-Augustins, Paris, c. 1950–51. Photograph: Denise Colomb

amination of each other's works, techniques, and innovations. As Picasso said, "No one has ever looked at Matisse's painting more carefully than I; and no one has looked at mine more carefully than he." Matisse honored the relationship by saying, "Only one person has the right to criticize me. . . . It's Picasso."

Picasso
Self-Portrait with Palette 1906

Matisse
Self-Portrait 1906

In *Self-Portrait with Palette* Picasso shows himself as an artist, holding in his left hand the palette a painter uses for mixing colors. We can see white, orange, black, and brown splotches of paint along the palette's bottom edge, and a shape that looks like Picasso's thumb poking through the hole above them. His right arm is bent, its shirt sleeve rolled up, and he holds his hand in a fist. He had actually considered putting a paintbrush in this hand but changed his mind, leaving the fist empty. Both Picasso and Matisse often changed their minds while they were working, allowing each artwork to develop and transform in the process of its making; their paintings result from sequences of choices and decisions. This particular decision has been seen by some as a tribute to the painter Paul Cézanne, who had recently died. It is as if the young Picasso were briefly putting down his tools in honor of the great French master.

Shortly before Picasso painted *Self-Portrait with Palette* he had visited Spain, where he had seen ancient Iberian carvings of faces made up of simple shapes. He had seen similar sculptures, as well as classical Greek and Roman sculptures, in the Louvre museum in Paris, and they strongly affected his rendering of the face in this painting. The blank, wide-eyed stare and the neatly oval shape of the head in particular show Picasso's interest in the simplified and abstracted shapes of ancient Iberian sculpture. Picasso's broad, flatly painted chest, white shirt, and simplified collarbone add to the stylized look of *Self-Portrait with Palette*. Behind

him a field of small, scratchy gray brushstrokes fills the background.

These classical and Iberian influences can be seen in the faces in a number of Picasso's works of this period. When Picasso painted *Self-Portrait*

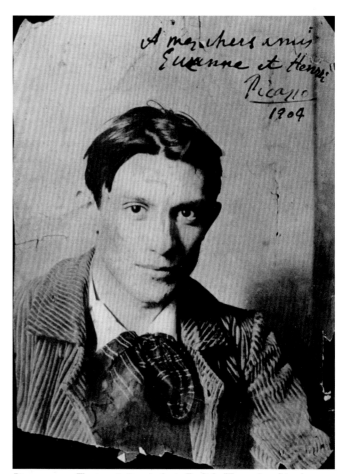

Picasso, 1904. The inscription reads, in English, "To my dear friends Suzanne and Henri [Bloch]. Picasso, 1904." Photograph: Ricardo Canals

with Palette, in fact, he was also working on a portrait of the writer and art collector Gertrude Stein, and the faces in *Self-Portrait with Palette* and in *Portrait of Gertrude Stein*—which he finished in the same year—are almost identical.

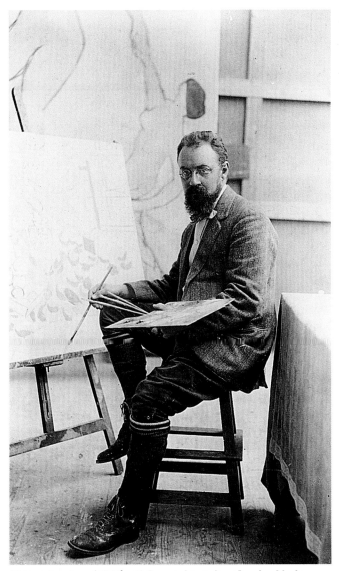

Matisse at work on *Still Life with Dance* in his studio at Issy-les-Moulineaux, Paris, probably in the fall of 1909. In the background is *Dance I*. Photograph: Alvin Langdon Coburn

Matisse painted *Self-Portrait* in 1906, the same year Picasso painted *Self-Portrait with Palette*. The artist's large dark eyes stare directly out at us, sandwiched between wide swatches of green paint suggesting shadows on his forehead and cheek. His features seem carved of thick black lines, which combine with patches of paint in varying shades of green and blue to define the angles of his face. The entire painting is covered with brushstrokes that slash energetically across its surface. These bold marks, and the work's startling colors, are characteristic of Fauvism, an important new movement in painting at the time—Matisse would be called the "King of the Fauves" for his leading role in this group. "You begin painting well when your hand escapes from your head," he once said, and that idea is reflected in the unnatural colors and spontaneous-looking brushstrokes of *Self-Portrait*.

Picasso and Matisse painted these two works early in their careers and shortly after they first met. In both of these assertive self-portraits the figure takes up most of the canvas on which it appears, recalling the monumentality of Cézanne's figure compositions. The artists depict themselves with varying degrees of simplification and abstraction. Each self-portrait highlights particular aspects of their respective approaches and interests: Picasso limits his colors to a monochromatic palette reminiscent of the ancient stone sculpture he had been looking at; Matisse chooses surprising colors in which to paint himself. Matisse gives himself a penetrating gaze; Picasso's eyes seem somehow disengaged, reflecting his interest in the abstract features of Iberian and classical sculpture. Both artists are influenced by Cézanne in very specific ways: for Picasso the construction of form through shape; for Matisse the construction of form by means of color. While Matisse is challenging people's ideas about how to use color, Picasso is simplifying shapes to their most basic forms.

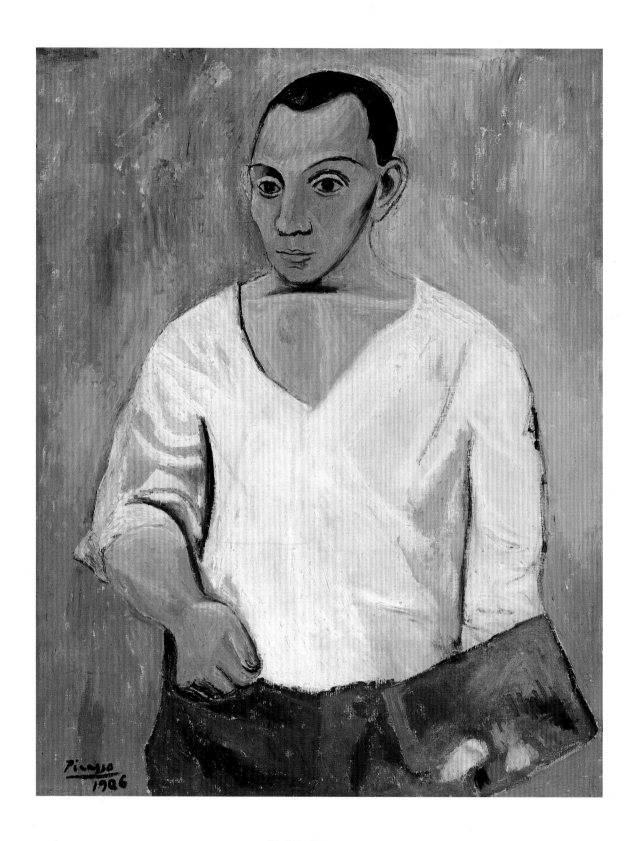

Pablo Picasso
Self-Portrait with Palette (Autoportrait à la palette). 1906. Oil on canvas, 36 ¼ × 28 ¾" (91.9 × 73.3 cm).
Philadelphia Museum of Art. The A. E. Gallatin Collection

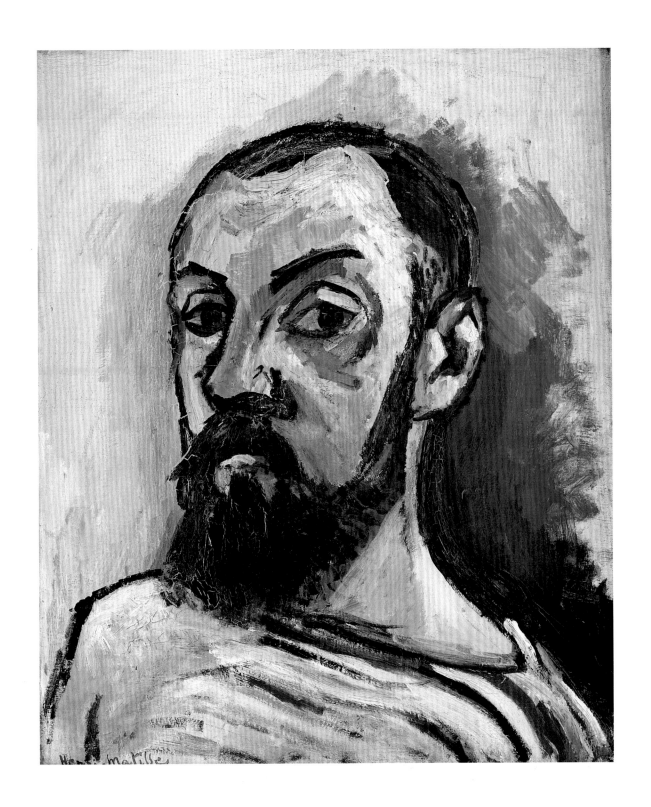

Henri Matisse
Self-Portrait (Autoportrait). 1906. Oil on canvas, 21⅝ × 18⅛" (55 × 46 cm).
Statens Museum fur Kunst, Copenhagen. Johannes Rump Collection

Matisse
Violinist at the Window 1918

Picasso
The Shadow 1953

Matisse and Picasso painted self-portraits throughout their working lives. Matisse was nearly fifty in 1918, when he painted *Violinist at the Window*, and Picasso was seventy-two in 1953, when he painted *The Shadow*. Although the two works were made many years apart, and at very different stages of the artists' careers, they bear striking visual and thematic similarities.

Violinist at the Window shows a solitary man facing away from us out a French window and playing the violin. His long mustard-colored suit is abstracted into a few simple shapes, defined with black lines and filled in with washy color. His head is a translucent white-and-yellow oval through which we can faintly see the panes of the window beyond him. The single most detailed part of his body is his left hand, its fingers curling around the neck of the violin. Outside the window an enormous cloud fills most of the sky. The strip of sky above the cloud is colored a strange dark-orange. Bright, cool-looking daylight enters the window, highlighting parts of the man's body and a section of the diamond-patterned floor beneath his feet.

Violinist at the Window is generally considered a self-portrait, painted after Matisse moved to Nice, in the South of France, late in 1917. Some think it shows Matisse's son Pierre, whom Matisse had several times depicted practicing the violin and the piano, but Pierre himself, when asked about this years later, insisted that the picture showed his father. A few years earlier, in the fall of 1914, Matisse had taken violin lessons, and when he painted this picture he was practicing the violin for an hour every day. Around this time he confided to his wife that he had a fear of losing his sight. Looking for a way to support himself and his family in the face of such a calamity, he practiced his instrument religiously.

The orange sky suggests Nice's sunny warmth, but its dark color seems slightly ominous, and *Violinist at the Window* has a pervasive air of melancholy. It seems to allude to anxieties both personal and public: Matisse's fear of losing his creative abilities, and the worry and grief of World War I, which had yet to end. Around the time Matisse painted *Violinist at the Window*, his sons, Pierre and Jean, had enlisted in the armed forces. Perhaps these circumstances contributed to the contradiction between the painting's bright light and its somber color and tone. Matisse chose not to exhibit this work during his lifetime.

Picasso said that the large black silhouette emerging from the bottom of the picture in *The Shadow* was himself. The scene is the artist's studio. Picasso painted the silhouette without much detail, but it appears to be facing away from us—we are seeing the artist with his back to us, gazing at a painting of a reclining female nude that is propped up in the corner of the room. The edges of this image of a nude are visible on the wall and the objects behind it, as though they were spilling off the canvas, or as though it were not a solid painting but a transparent slide projected across one wall of the studio and everything nearby. In fact everything in *The Shadow* except Picasso's flat black silhouette

seems to consist of shifting, mainly rectangular transparencies. Perhaps Picasso is suggesting that this image of a woman is somehow a projection of his imagination—which, of course, is true. *The Shadow* connects us with Picasso in that it places us just behind him, gazing in at his studio over his shoulder, contemplating the same view.

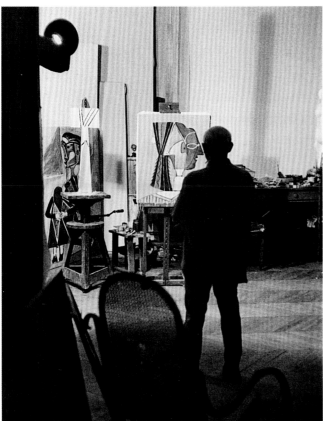

Picasso in his studio at La Californie, his villa near Cannes, 1957. Photograph: David Douglas Duncan

Picasso painted *The Shadow* at the very end of 1953, in the few days between Christmas and New Year's. The year had been a turbulent one for him, filled with public successes and personal difficulties: he had had major retrospective exhibitions in Italy, France, and Brazil, but in the fall Françoise Gilot, with whom he had lived for years, had left him. That Christmas she took their children, Claude and Paloma, to stay with her for the holidays, leaving Picasso by himself.

Violinist at the Window and *The Shadow* were painted far apart in time, but when both men were middle-aged or older. The paintings show the two artists musing on mortality and on loss. When Picasso painted *The Shadow*, Matisse was quite ill— he died the following year. The artists were at this point very close, and Picasso visited Matisse often. Perhaps the illness of the older painter, Picasso's friend and only true rival, combined with other losses in his life to remind him of his own mortality.

In each of these paintings we stand behind the artist as he reflects upon a subject he used repeatedly, and also upon art itself. Matisse shows himself gazing out his window, a view he offered many times to the viewers of his paintings. He also depicts the theme of music, which he addressed throughout his career, and paints himself as the musician. Picasso meanwhile explores his own relationship to the figure he paints, showing himself simultaneously as the viewer and the artist. He casts his shadow over and into the canvas, as though he were merging with his art; and the art meanwhile seems to expand past its own boundaries and leak out into the room. It is as if both artists were suggesting that the artist and the artwork are one and the same.

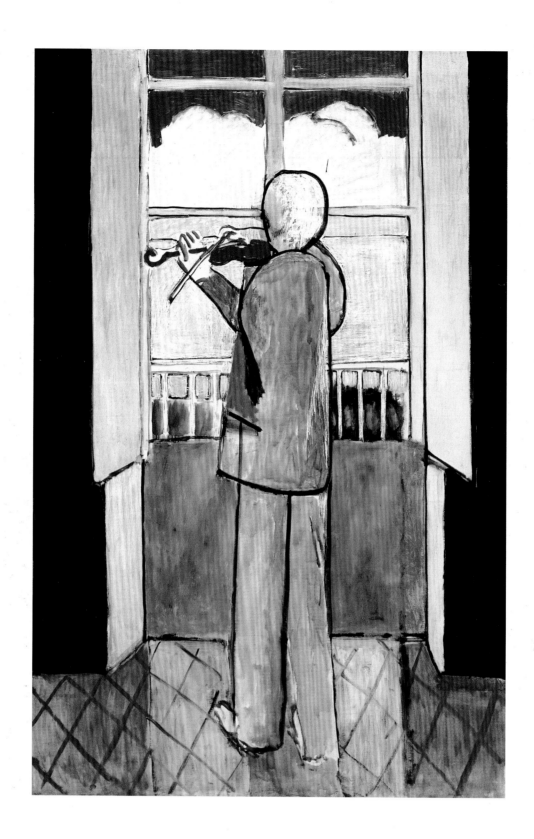

Henri Matisse
Violinist at the Window (Le Violoniste à la fenêtre). 1918. Oil on canvas, 59 × 38½" (150 × 98 cm).
Centre Georges Pompidou, Paris. Musée National d'Art Moderne/Centre de Création Industrielle

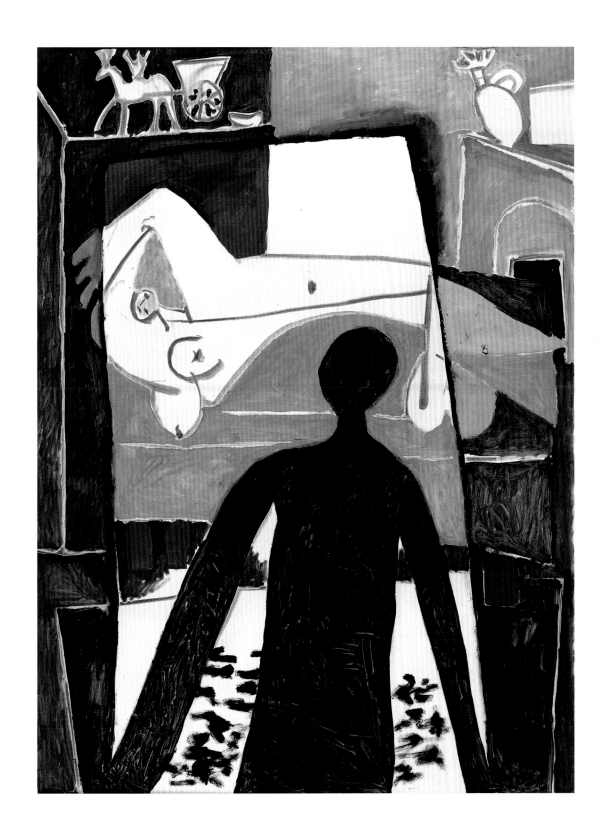

Pablo Picasso
The Shadow (*L'Ombre*). 1953. Oil on canvas, 49½ × 38" (125.5 × 96.5 cm).
Musée Picasso, Paris

Matisse
Le Luxe I 1907

Picasso
Boy Leading a Horse 1906

oy Leading a Horse shows a nude boy and a horse in a dusty brown landscape. The boy faces ahead, his left hand on his hip, his right foot stepping forward. The gray and white horse beside him mirrors his pose, also facing ahead with its right leg forward. The boy holds his right arm in front of the horse's body. His hand is clenched as if it held a pair of reins, but it is empty; still, the horse behaves as if commanded by this mysterious gesture. The boy's expressionless face adds to the picture's strangeness.

Before Picasso painted *Boy Leading a Horse* he had been a regular visitor to the Cirque Médrano, a Paris circus not far from his home in the artist neighborhood of Montmartre. The performers there reminded him of the traveling entertainers he had seen as a child in Spain; they also interested him as social outsiders, just as he and the artists he knew were at the time. Finally, he appreciated the ability of the circus people to communicate through performance, a skill he identified with his own ability to communicate through painting. As a result, Picasso created many pictures of circus people, such as *Two Acrobats and a Dog* (1905), which shows two boys and their dog in an empty-looking landscape rather like the one in *Boy Leading a Horse*— a barren world inhabited by isolated figures. *Boy Leading a Horse* relates to the circus pictures, but Picasso has removed obvious references by painting the boy nude. He had often looked at ancient sculptures in the Louvre museum in Paris, among them Greek Kouros figures showing nude young

men standing with one foot forward, as the boy does in *Boy Leading a Horse*. Indeed, with his sturdy pose, his stillness, and his solid build, Picasso's figure looks almost like a sculpture.

The women in Matisse's *Le Luxe I* are as mysterious as Picasso's boy. Each figure faces in a different direction and seems lost in her own activity. The dark-haired woman to the left gazes absently downward. A blond woman crouches at her feet, examining the cloth she stands on. Behind them runs another woman holding flowers. The background is divided into wide horizontal bands: the ground under the women's feet is a yellowish brown; behind them is a roughly painted green-blue area that looks like water; in the distance are three hills and a sky half-filled with an enormous cloud.

In 1905–6 Matisse had created a painting called *Le Bonheur de vivre* (The happiness of living). This imaginary landscape, with its nude figures relaxing under the trees as if in some story or classical myth, was a source for some of his later artworks, including *Le Luxe I*. In fact the crouching woman in *Le Luxe I* originally appeared in *Le Bonheur de vivre*, although she faced in the opposite direction. Both works borrow from the Arcadian tradition in painting, that is, the tradition of depicting an ideal land where people live in harmony with nature. Matisse's rendering, however, is looser and sketchier than that tradition would generally have allowed. The fact that the women in *Le Luxe I* are so close together yet seem so disconnected from each other adds to the painting's unconventionality. *Le Luxe I* is related to *Le Bonheur de vivre* thematically as well as formally: "*luxe*" is the French word for "luxury,"

Pablo Picasso. *Two Acrobats with a Dog.* 1905. Gouache on cardboard, 41½ × 29½" (105.5 × 75 cm). The Museum of Modern Art, New York. Gift of Mr. and Mrs. William A. M. Burden

makes these works modern: unlike the narrative images of earlier traditions, they refuse to tell a clear story. The sketchy, even willfully awkward way in which all three works are painted is also a part of their modernity. Picasso is experimenting with an almost sculptural approach to the figure, Matisse with flat areas of color, but both paintings look roughly painted and unfinished, just as Cézanne's *Bather* does.

Both artists were borrowing from tradition in these paintings, but updating it by painting ambiguous situations in unconventional ways. In fact Matisse and Picasso were moving away from creating pictures that tell stories. They used a story's basic parts—character, action, location—but they eliminated many of its details, preventing us from "reading" it too easily. They invite us to imagine a meaning but don't let us arrive at a conclusion.

and here refers to the pleasure of life—"the happiness of living."

The painter Paul Cézanne was a great influence on Matisse, Picasso, and their peers. Cézanne explored the shape and structure of things in his paintings. Picasso once said of him, "It was the same with all of us—he was like our father." Cézanne was fascinated by the theme of bathers—Matisse's subject in *Le Luxe I,* and one he would explore throughout his life. Similarly, the figure's pose and the empty landscape in Cézanne's painting *The Bather* (c. 1885) resemble those in Picasso's *Boy Leading a Horse.*

Like Cézanne, Picasso and Matisse provide few details to suggest their subjects' identities or whereabouts. The resulting ambiguity is one thing that

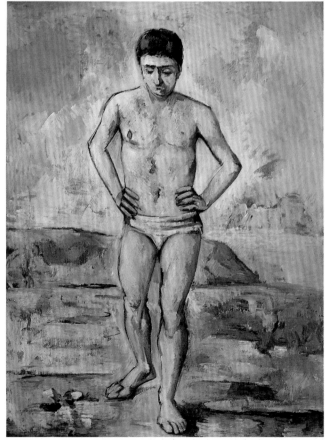

Paul Cézanne. *The Bather.* 1885. Oil on canvas, 50 × 38⅛" (127 × 96.8 cm). The Museum of Modern Art, New York. Lillie P. Bliss Collection.

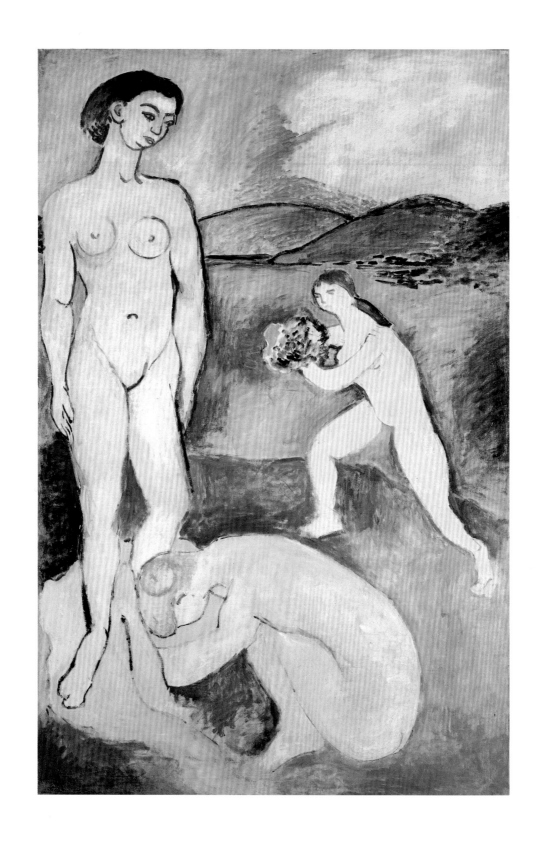

Henri Matisse
Le Luxe I. 1907. Oil on canvas, 7′ 10⅝″ × 54⅜″ (210 × 138 cm). Centre Georges Pompidou, Paris.
Musée National d'Art Moderne/Centre de Création Industrielle

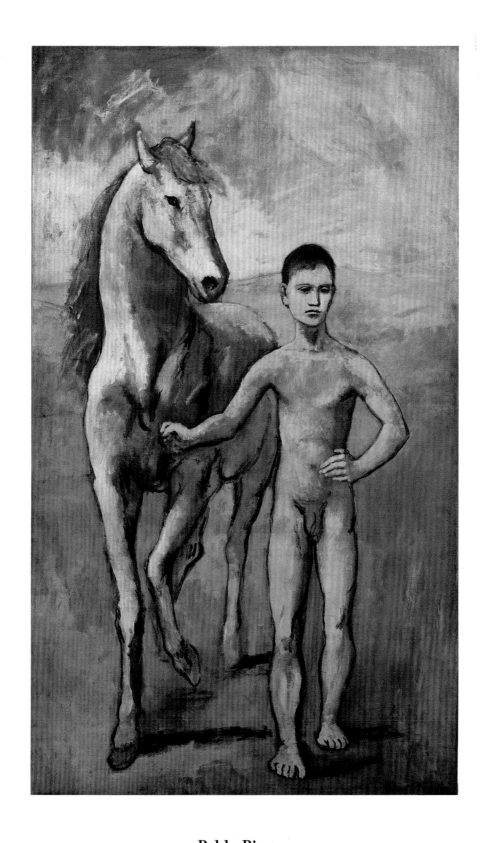

Pablo Picasso
Boy Leading a Horse (Le Meneur de cheval). 1906. Oil on canvas, 7' 2¾" × 51½" (220.6 × 131.2 cm).
The Museum of Modern Art, New York. The William S. Paley Collection

Picasso
Les Demoiselles d'Avignon 1907

Matisse
Bathers with a Turtle 1908

When Matisse exhibited *Le Bonheur de vivre* (The happiness of living, 1905–6) in 1906, many people were shocked at his use of color and at the way the figures seemed disconnected from each other within the painting. But Leo and Gertrude Stein bought the painting immediately, and Picasso probably first saw it in their apartment. *Le Bonheur de vivre* may have been one of the inspirations for *Les Demoiselles d'Avignon*, which Picasso completed the following year.

Les Demoiselles d'Avignon shows five nude women. The woman on the left stands facing the center of the picture. She holds one hand up against a long reddish-brown shape that looks like a curtain. The two women in the center look straight out at us with wide-eyed stares and expressionless faces. One of them raises an arm behind her head and holds a white cloth draped over her leg; the other bends both arms behind her head, as if she were posing for an audience. A fourth woman stands and a fifth woman squats on the right. Their faces are dramatically distorted, with sharp angles, rough lines, and colors that clash with the rest of their bodies. At the bottom of the painting is a small arrangement of fruit. The background, like the women's bodies, is made up of irregular, angular shapes.

Picasso has deliberately avoided any sense of harmony. The picture seems illogical; the woman on the left, the two in the center, and the two on the right might have come from three different paintings. Even the body parts of individual figures don't seem to match up. The effect is jarring, challenging us to make sense of the work one section at a time. Alfred H. Barr, the first director of The Museum of Modern Art, once said that in the *Demoiselles* "the transformation of Picasso's ideas can be seen taking place right before our eyes."

Some of the sketches Picasso did to work out the composition of the *Demoiselles* show men as well as women, but in the end he included just women. The painting's title, made up by a friend of Picasso's, the writer André Salmon, refers to "the girls of carrer d'Avinyo" (Avignon Street), a street in a red-light district in Barcelona, a city where Picasso had once lived. The female nude is a long tradition in Western art, but the irregular, angular, distorted figures in the *Demoiselles* break from that tradition decisively. Gazing steadily out at us, they aggressively confront our reactions to them.

Around May or June of 1907, shortly before he finished the *Demoiselles*, Picasso visited the Palais du Trocadéro, a Paris museum showing objects from non-Western cultures, including African sculptures and masks. Matisse later claimed to have introduced Picasso to African objects, which he had begun to collect a little earlier, but according to Picasso this visit was a moment of awakening for him. In any case, the *Demoiselles* shows African influences, particularly in the masklike faces of the two women on the right and the one at the left. It also echoes ancient Iberian sculpture, which Picasso had seen in Spain and at the Louvre.

Les Demoiselles d'Avignon created an enormous stir among visitors to Picasso's studio. Matisse and

Leo Stein saw the painting in the fall of 1907, and reacted to it negatively. The painters André Derain and Georges Braque disliked it too, and the art dealer Ambroise Vollard even said, "It's the work of a madman." Finally, the writer André Breton said, "There is nothing left but to declare oneself for it or against it." Picasso chose not to exhibit the work publicly until 1916.

Matisse painted *Bathers with a Turtle* in early 1908, a few months after seeing the *Demoiselles*. At the left of this large work, a blond woman crouches and holds out her hand to a turtle. In the center stands a black-haired woman who gazes down at the turtle, her hands at her mouth, completely absorbed. On the right sits another woman, her head and back one graceful curve. She seems to float in a horizontal band of green, although slight shadows at her thigh and back suggest where she might be sitting.

In *Game of Bowls*, also painted in 1908, Matisse shows three nude men in poses similar to the women in *Bathers with a Turtle*. They too seem engrossed in a group activity, and the background is similarly constructed of three wide horizontal bands of green and blue, evoking earth, water, and sky. Matisse often depicted the same theme or subject more than once, sometimes many times. In fact the crouching woman in *Bathers with a Turtle* looks like the mirror image of a woman in *Le Luxe I*, who in turn had appeared in *Le Bonheur de vivre*. Unlike *Le Bonheur de vivre*, though, the two later paintings show the figures interacting in a unified way, even if it is hard to tell exactly what they are doing or where they are.

Both *Les Demoiselles d'Avignon* and *Bathers with a Turtle* are large paintings of nude figures in mysterious environments. More important, both show Matisse and Picasso continuing to move away from the tradition of Western painting, proclaiming a new and modern way of making art. Yet the works invite quite different reactions. The women in the *Demoiselles* face out defiantly, challenging us to look at them, engaging us directly with their poses and stares; the figures in *Bathers with a Turtle* face inward, inviting us to share in their contemplation. And where Picasso composes the *Demoiselles* out of rugged shards, Matisse paints expanses of color, adding to the calmness of the scene.

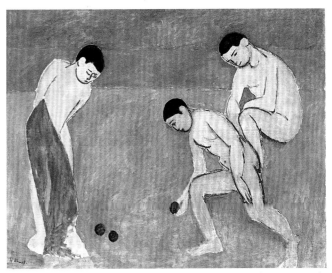

Henri Matisse. *Game of Bowls*. 1908. Oil on canvas, 44⅝ × 57" (113.5 × 145 cm). The State Hermitage Museum, St. Petersburg

Picasso and Matisse continued in their experiments even at the risk of threatening their relationships with important collectors of art. Around this time, for example, Leo Stein, who regularly purchased their work, was beginning to have doubts about them as artists; his support for Picasso in particular began to waver after he saw the *Demoiselles*. Meanwhile his sister, Gertrude Stein, was favoring Picasso while staying friendly with Matisse. Yet through these tensions Picasso and Matisse remained supportive of each other. In the fall of 1908, in fact, Matisse brought the Russian businessman Sergei Shchukin to Picasso's studio; Shchukin had already amassed a great collection of recent and contemporary French art, and he eventually bought many paintings by both artists. Despite the competition between them, Matisse clearly believed strongly enough in Picasso to want to introduce the Spanish artist to one of his own greatest supporters.

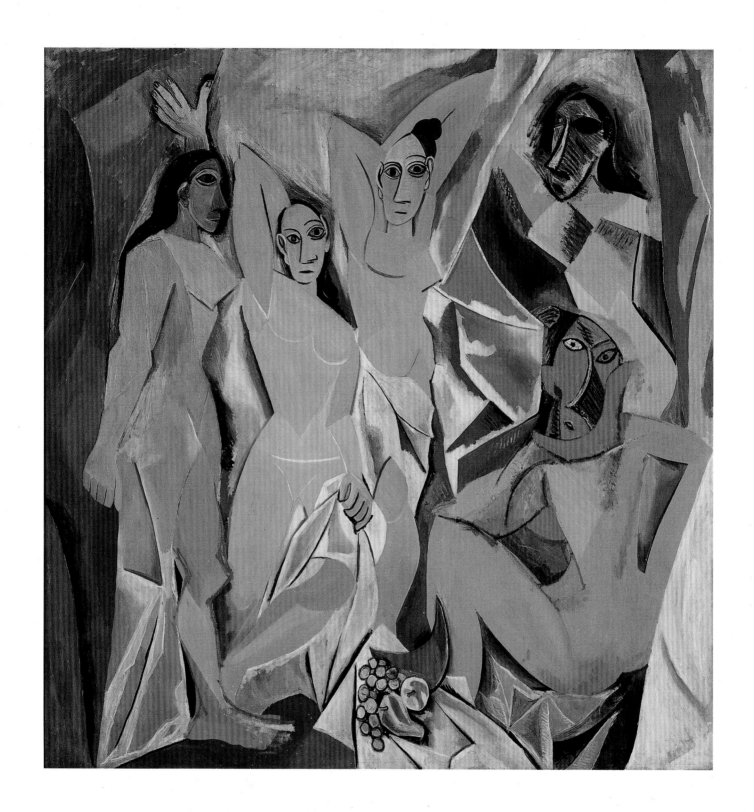

Pablo Picasso

Les Demoiselles d'Avignon. 1907. Oil on canvas, 8' × 7'8" (243.9 × 233.7 cm). The Museum of Modern Art, New York. Acquired through the Lillie P. Bliss Bequest

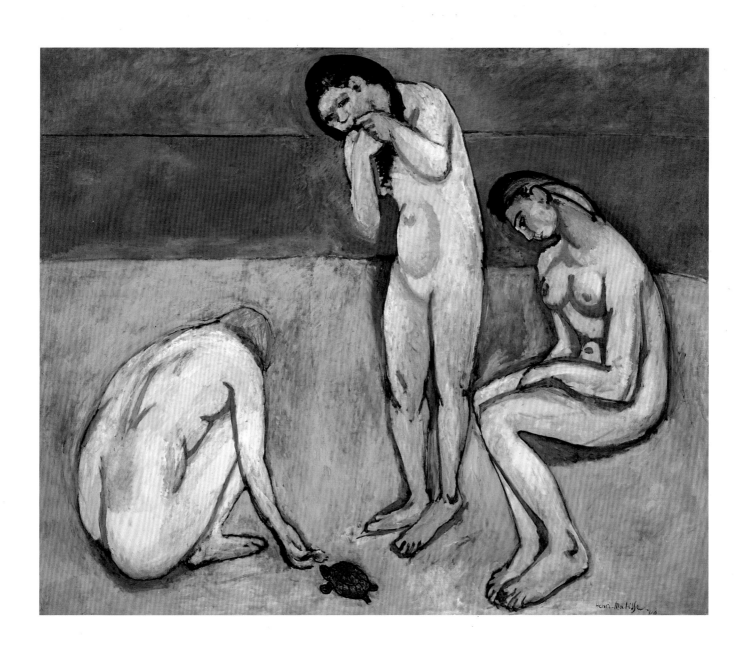

Henri Matisse
Bathers with a Turtle (Baigneuses à la tortue). 1908. Oil on canvas, 70 ½" × 7' 3¾" (179 × 220 cm).
The Saint Louis Art Museum. Gift of Mr. and Mrs. Joseph Pulitzer, Jr

❦ 23 ❧

Picasso

Pitcher, Bowl and Lemon 1907

Matisse

Portrait of Marguerite 1906

Early on in their careers, in the fall of 1907, Picasso and Matisse exchanged the paintings *Pitcher, Bowl and Lemon* and *Portrait of Marguerite*. There are many conflicting stories about the trade: some say that each artist chose which of his works to give to the other, some that each one made his own choice from the other artist's studio. As for why they ended up with these particular pictures, the most straightforward account of the swap is that they thought these paintings were the ones that best represented their work. Other accounts are less generous: Gertrude Stein, who displayed works by Picasso and Matisse on the same wall of her apartment, remembered that each artist chose the worst example of the other's work, wanting a painting that displayed the other's weaknesses. There are stories that visitors to Picasso's studio joked about *Portrait of Marguerite*, even throwing things at it. Supposedly, though, Picasso came to its defense, asserting years later that he had always considered it a key picture. Whatever the truth or falsity of these differing accounts, it is clear that early in their friendship these artists wanted to own each other's work.

Shortly before Picasso gave *Pitcher, Bowl and Lemon* to Matisse, he had created the highly controversial painting *Les Demoiselles d'Avignon*, whose distorted figures, jagged shapes, and stylistic inconsistencies shocked many of its viewers. Matisse had responded angrily to the notorious work, believing that in creating it Picasso was mocking the modern art movement. Yet there are clear visual similarities between the *Demoiselles* and *Pitcher, Bowl and Lemon*, both painted in 1907: at first glance, both appear to be made up of a cluster of angular geometric shapes. In *Pitcher, Bowl and Lemon*, sharp, roughly painted forms surround the still life in the middle of the picture. They strangely appear to be behind and in front of the objects at the same time, making it impossible to tell exactly where the still life is placed. Picasso also offers us several points of view on the pitcher and bowl themselves, allowing us to see them from the side and from the top simultaneously. The entire painting is arranged like a crumpled pinwheel, with lines from the top, bottom, and sides converging at its center.

Portrait of Marguerite, on the other hand, is arranged like a traditional portrait. The sitter—Matisse's eldest daughter, painted when she was a young girl—is seen from the chest up, facing out at us. Her pale, peach-colored face and neck are framed above by her dark hair and below by her blue-green blouse, and are punctuated by the black collar around her neck, which she wore to cover the scar from an operation. Her graceful features are made up of simple brushstrokes, such as the single dark line that begins at the outer edge of her right eyebrow and curves down her face to form the shape of her nose. A black line defines the neck of her blouse. The contrast between the black of the neckline and collar and the peach of her skin makes her face and neck pop forward visually.

Initially *Portrait of Marguerite* seems simply painted, almost childlike, but the longer we look at it the more we see how intentional Matisse's decisions are. He covers the entire surface in washy, irregu-

lar-looking brushstrokes, and makes unpredictable color choices—the black and green of Marguerite's hair, for example. Yet Matisse places his brushstrokes

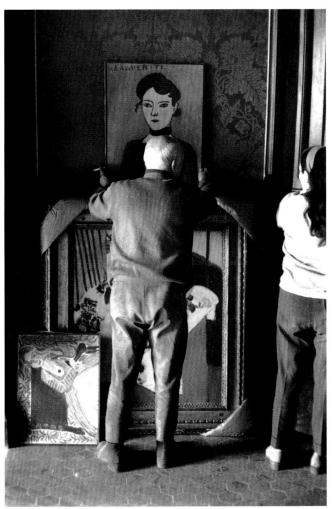

Pablo Picasso and Jacqueline Roque at home in Vauvenargues, 1959. Matisse's *Portrait of Marguerite* is on the wall, his *Still Life with Basket of Oranges* and *Seated Girl in a Persian Dress* stand on the floor. Photograph: David Douglas Duncan

very precisely, and defines Marguerite with a few areas of color. Adding to the childlike quality are the large capital letters at the top of the picture, spelling out his daughter's name. By including these,

however, Matisse not only adds to the work's already whimsical feel but reminds us that a painting is a flat surface, whatever its illusion of depth.

Pitcher, Bowl and Lemon and *Portrait of Marguerite* highlight dramatic differences in the two artists' approaches to painting. Picasso's picture is made up of severe angles, energetically crowding the composition; Matisse's tranquil portrait seems composed of a few lines dividing broad areas of largely flat color. Although these paintings might once have seemed insignificant, and somewhat crudely realized, both of them demonstrate something essential about their maker's work.

Each artist would go on to own a number of works by the other. In 1942, for example, Picasso bought Matisse's *Still Life with Basket of Oranges*, a painting of a shallow basket, overflowing with oranges, on a floral-patterned tablecloth. Brightly colored cloths draped behind the still life form the background. Unlike *Portrait of Marguerite*, *Still Life with Basket of Oranges* is filled with colors and patterns, showing the influence of the textiles Matisse saw during his visits to Morocco. In fact he painted this work during a visit to Tangier in 1912.

Matisse and Picasso had deep and frequent creative differences, but when Matisse heard that his friend and rival had purchased *Still Life with Basket of Oranges*, he was truly touched. It was important to him that the two men should own each other's work. The purchase was also significant to Matisse because most of the paintings he had made in Tangier in 1912 had been bought by foreign collectors. *Still Life with Basket of Oranges* had been owned by a German collector in Berlin; in buying the work, Picasso had returned it to France.

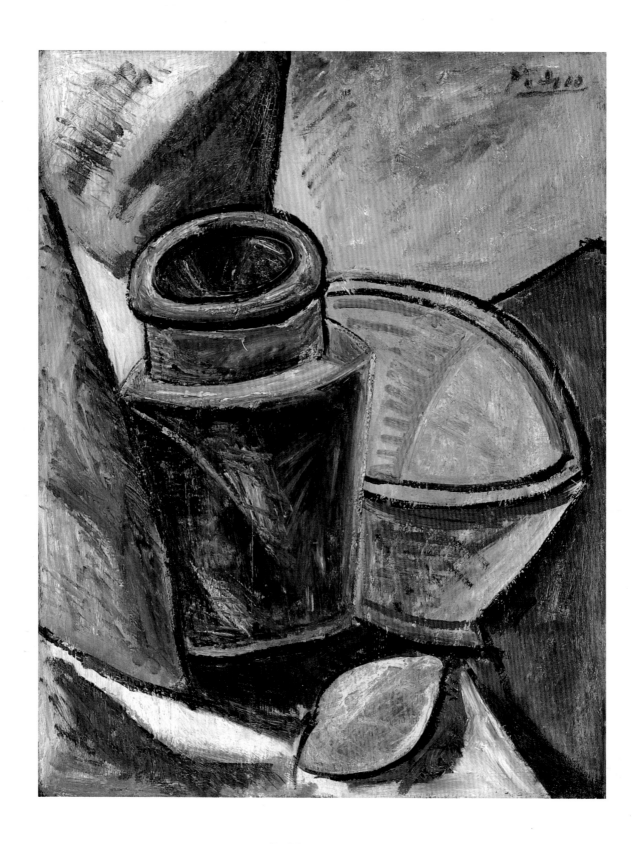

Pablo Picasso

Pitcher, Bowl and Lemon (Cruche, bol et citron). 1907. Oil on wood, 25 × 19½" (63.5 × 49.5 cm).
Private collection. Courtesy Beyeler Foundation, Riehen/Basel

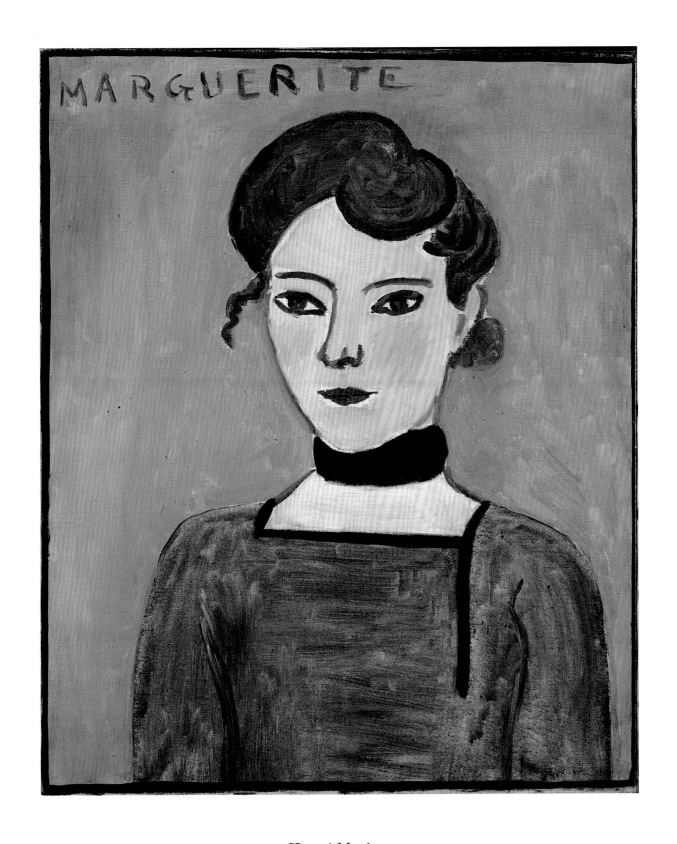

Henri Matisse
Portrait of Marguerite (Portrait de Marguerite). 1906. Oil on canvas, 25½ × 21¼" (65 × 54 cm).
Musée Picasso, Paris

Matisse
Goldfish and Sculpture 1912

Picasso
Still Life with a Skull 1907

Matisse's *Goldfish and Sculpture* shows a wide glass beaker holding three brilliantly colored goldfish. Placed next to it is a small vase overflowing with three leafy flowers. To the right, at an angle, lies a peach-colored sculpture of a nude woman, her ankles disappearing off the painting's corner. The woman leans easily on her right arm, and lifts her left arm to tuck her hand behind her head. Black lines define the shape of her body, while her face is made up of a jumble of smudged paint.

These objects seem to float in a pool of brilliant blue paint, which covers most of the background. The white of the canvas shows through the blue paint—and the result is the feeling of a room filled with light. The tabletop on which the objects rest is suggested only by two thin lines, which blend into the background. The sculpture extends past the right and front edges of the table, making the table appear to tilt. Adding to the confusing sense of space is the fact that the table seems to disappear into the background—its far end and right side are completely unmarked.

Behind the objects is a wide rectangle, a window or doorway. It is divided into three bands of color, broken by wavy black lines and green smudges of paint that look like leaves. Matisse makes these simple shapes and colors hint at the landscape outside the room. To the right is an olive-colored shelf, whose supports seem to touch the sculpture's raised elbow. Above the shelf is a square resembling a mirror or a picture.

Much of *Goldfish and Sculpture* has been painted in small clusters of brushstrokes with bare canvas peeking through among them. This loose texture makes us think of the movement of Matisse's hand in the act of painting; we can almost imagine him pulling the paint across the canvas, in quick, sketchy strokes.

Matisse painted *Goldfish and Sculpture* between two visits to Morocco in 1912. There, in Tangier, he is likely to have seen goldfish in bowls in the marketplace. He associated goldfish with foreign cultures that interested him, such as those of North Africa and the Far East. He was also fascinated by the peacefulness of the fishes' movement and by their bright, translucent color, which invited contemplation. Matisse painted goldfish throughout his life. In *Goldfish and Sculpture* he connects art and nature by including sculpture, cut flowers, and swimming goldfish in a single still life.

The sculpture depicted in the painting is Matisse's *Reclining Figure I (Aurora)*, from 1907. This work was an adaptation of a figure from Matisse's painting *Le Bonheur de vivre* (1905–6), a work that many believe was one inspiration for Picasso's picture *Les Demoiselles d'Avignon* (1907). Matisse included images of his own work in other paintings as well. In *The Red Studio* (1911), he also decided to flood the canvas with a single color, a vibrant red, just as he had made *Goldfish and Sculpture* primarily blue. Acting as a backdrop, this red makes the objects and artworks in Matisse's studio stand out from the rest of the picture. It also makes us notice the flatness of the canvas, undermining the illusion that we are seeing the space of a room. The objects Matisse paints

in other colors besides red are almost exclusively his artworks, the materials of his art, and the subjects he frequently portrayed in his art. Most of the furniture appears only in outline. By painting his artworks in full color and letting the furniture, walls, and floor blend uniformly together, Matisse

Henri Matisse. *The Red Studio*. 1911. Oil on canvas, 71¼" × 7' 2¼" (181 × 219.1 cm). The Museum of Modern Art, New York. Mrs Simon Guggenheim Fund

tells us what to focus on in this painting: his life and work as an artist. He has arranged his studio like an exhibition, showing us the development of his work. *The Red Studio* can be thought of as a self-portrait of the artist without the artist.

Picasso's *Still Life with a Skull* looks like a clutter of objects stacked haphazardly on top of each other: a narrow human skull rests between a pile of books, a pipe, and an oddly shaped cup on a plate. Under these objects lies a bright pink cloth bunched up in sharp folds. Above them the corner of a painting juts out from behind the pink cloth. This painting shows part of a figure on a blue background, a

woman with her arm up over her head—rather like the women in a number of Picasso's paintings from this period. To the left of this painting is a palette with brushes fanning out from the thumb hole. A jumble of curves and shapes resembling one of Picasso's landscapes fills the background.

Picasso has painted a cramped space crowded with things in his studio: his paintings, a selection of still life objects, and his paintbrushes and palette, which remind us of him and of how he made this picture. Around the time that he painted *Still Life with a Skull*, a friend of his died. He may have painted the skull in response, but he was in any case continuing a long European tradition of including a skull in a painting to symbolize death. In either case, the crowded space and sharp angles of *Still Life with a Skull* create a sense of unease.

Goldfish and Sculpture and *Still Life with a Skull* exemplify both differences and similarities in the two artists' approaches to painting. Picasso packs his jagged forms so closely together, for example, that we cannot get a sense of the space in which they are located; rather than painting the objects as if they receded into the distance, he turns them upward as if they were standing on end. Matisse, on the other hand, makes his objects seem to hover in a tranquil, spacious room—although the way the table and the sculpture are vertically tipped up is similar to the composition of *Still Life with a Skull*. Both paintings create a confusing space in which it is hard to tell what is near and what is far. Matisse often depicts his earlier artworks in his paintings, but in *Still Life with a Skull* Picasso does this as well. Both works offer us a glimpse into the life of the artist through his surroundings and through his art.

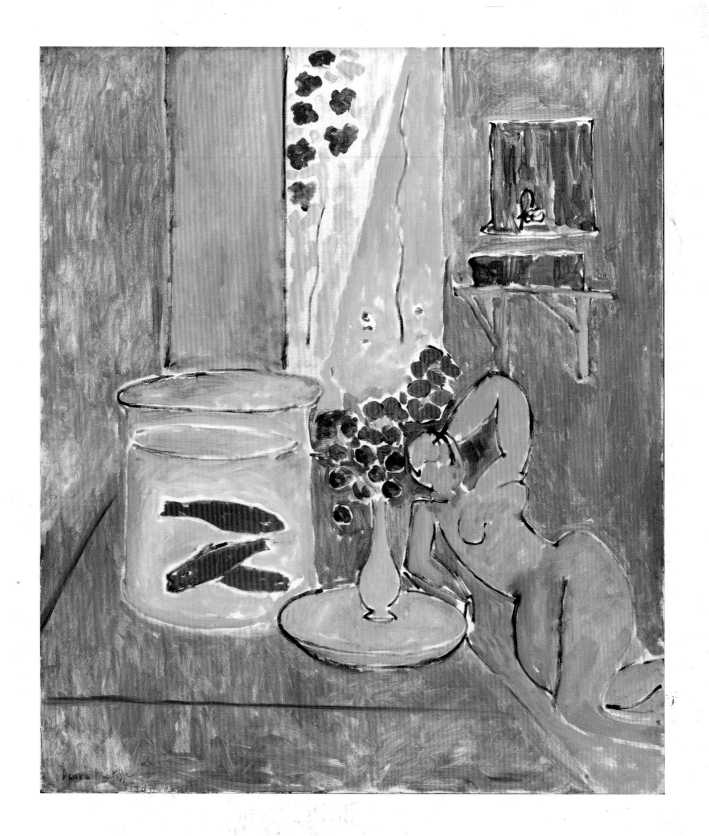

Henri Matisse
Goldfish and Sculpture (Poissons rouges et sculpture). 1912. Oil on canvas, 45¾ × 39⅝" (116.2 × 100.5 cm).
The Museum of Modern Art, New York. Gift of Mr. and Mrs. John Hay Whitney

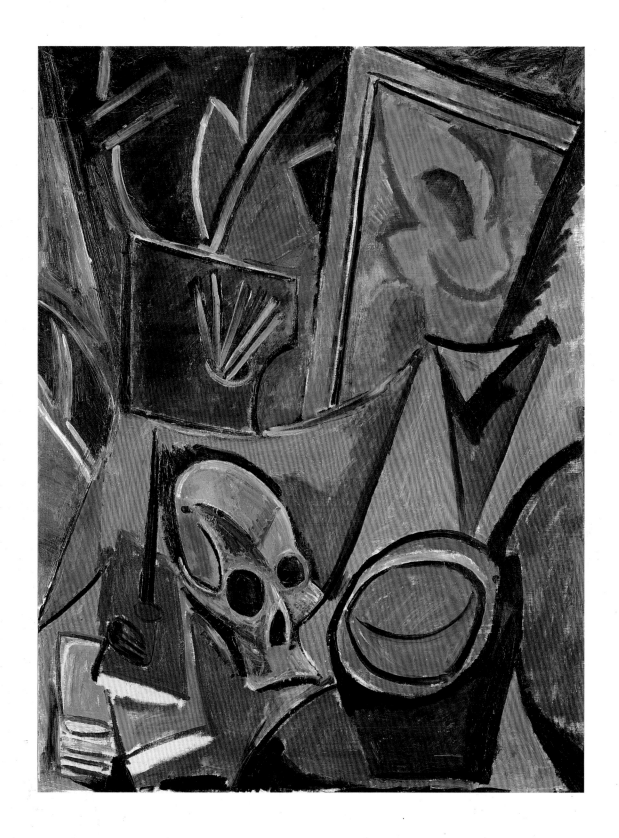

Pablo Picasso
Still Life with a Skull (Nature morte à la tête de mort). 1908. Oil on canvas, 45¾ × 35⅛" (115 × 88 cm).
The State Hermitage Museum, St. Petersburg

Picasso

The Guitar Player 1910

Matisse

View of Notre Dame 1914

Picasso met the painter Georges Braque in the fall of 1907, when he was in his mid-twenties. Around two years later the two men began working together to develop new forms of artmaking. By the time Picasso painted *The Guitar Player*, in 1910, they were working so closely that Braque described them as "roped mountaineers." Picasso for his part called Braque "Wilbur," referring to Wilbur Wright, who, with his brother Orville, had pioneered the airplane a few years earlier. Picasso was likening himself and Braque to the Wright brothers in their creative daring and experimentation. At times it was difficult to tell the two artists' works apart.

One of Picasso's and Braque's inventions was the style later called Analytic Cubism. In this phase of their work the artists were experimenting with breaking up forms into simplified angular shapes, in an effort to show them from several points of view at the same time. In trying to show things simultaneously from the front, the side, and above, Picasso and Braque were challenging the tradition that the subject of a painting should be described as if we were seeing it from a single viewpoint, as if glancing through a window. Showing a subject from several angles at once, on the other hand, evoked a progression of movement—the way we actually see things over time.

In their Analytic Cubist period Picasso and Braque used muted colors, mostly grays and browns, so that viewers of the paintings would focus on the way the forms relate to each other as they emerge from the dark background. The shapes are painted as if they were illuminated from many different directions. The visual appearance of the subject in these paintings is not an end in itself, it is a point of departure. Picasso and Braque took what they saw and dissected it, examining all the parts that made up the whole. Then they put it together again, using only its essential shapes.

In an Analytic Cubist painting, the different parts of the composition often do not match up. Picasso takes this visual contradiction to an extreme in *The Guitar Player*, mixing areas of shadow and light and constantly changing the direction of the painting's thin intersecting black lines. These lines, and the short choppy patterns of brown and gray brushstrokes, create a dense web of shapes in which the guitar player is almost impossible to make out. It is difficult to imagine him in these fragments; the planes and lines connect without clearly forming a person. Picasso is addressing the shapes and structures of things, not just their outward appearances.

The name "Cubism" seems to date from the autumn of 1908, when Braque submitted work to the Autumn Salon, an important annual exhibition. His work was rejected in part because of Matisse, who was one of the members of the jury that made the selections, and who supposedly said that Braque's paintings were made up of "little cubes." The phrase took root, probably because many people disliked Cubism when it first emerged—the collector Leo Stein, for example, called it "rubbish." But the name "Cubism" stuck after the public had changed their minds about the art. Even the poet Guillaume Apollinaire, who wrote enthusiastically about Cubism, called it by that name.

In the upper left corner of Matisse's *View of Notre Dame*, two tall rectangles that look as if they might be constructed out of building blocks form a U-shape. Behind this shape and partly hidden by it—but also visible *through* it—is a smaller, similar shape. An irregular patch of black creates a background to this straight-edged structure, which seems to hover in the air. At its lower right corner is a green, roughly oval form, presumably a tree or a group of bushes, from which a bold black line runs down and to the left. Several more black lines run diagonally, horizontally, or vertically through the picture, occasionally crossing. Blue brushstrokes are scratched across almost the entire surface. To the right is a trace of the scrolling forms of a balcony's ironwork, which quietly lets us know that we are seeing a view from a window.

Matisse painted this picture in his Paris studio at 19 quai Saint-Michel, from which he had a view of Notre Dame, the well-known medieval cathedral on an island in the Seine River. For many, the church lies at the very heart of the city. Describing the cathedral in *View of Notre Dame*, Matisse chooses to omit all of the ornate stone carvings that cover the building's walls. He also eliminates almost everything in his own studio, as well as the surrounding buildings. Some of the painting's straight black lines seem to suggest part of the studio, and perhaps the window frame, but the detail is absolutely minimal. Yet Matisse leaves in a smaller image of the cathedral's towers that he must have painted before the larger version, letting us see its sketchy lines through the larger structure.

In the few spare lines of the towers, Matisse simplifies Notre Dame to its most basic shape. He simultaneously reduces the building to an element in the landscape and reminds us of its iconic significance; he makes a familiar icon strange but still subtly recognizable. The muted color of *View of Notre Dame* may suggest the somber mood of Paris when he painted it, because of World War I, which began the same year. It may also show the influence of Cubism, and the restricted colors of paintings like *The Guitar Player*.

In the summer of 1913, Matisse and Picasso had been in close touch. They had worked in nearby studios and had met for walks and to go riding together.

Notre Dame from the window of Matisse's studio on the quai Saint-Michel, Paris. Photograph: collection Hélène Adant

Matisse may have disliked Cubist painting when he first saw it, but the effect of Cubism on *View of Notre Dame* is clear, in the lines dividing the picture, the simplification of the shapes, and the shallow space. As Matisse once said of Picasso, "There is no question that we each benefited from the other."

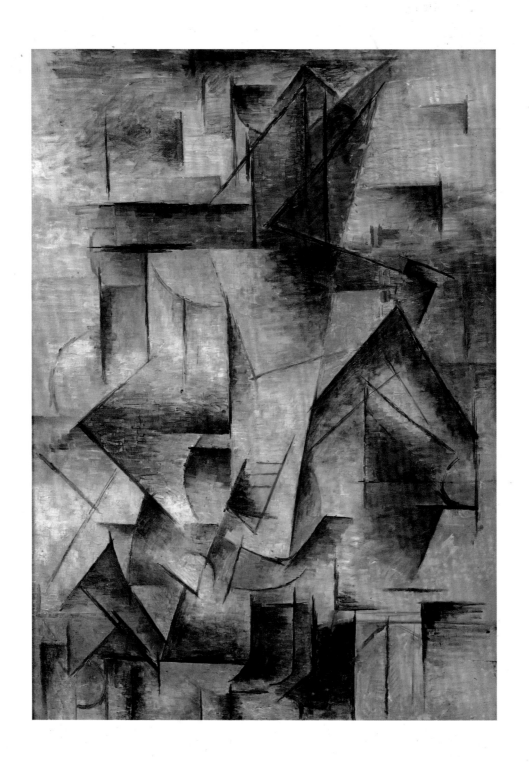

Pablo Picasso
The Guitar Player (*Le Guitariste*). 1910. Oil on canvas, 39³/₈ × 28 ³/₄" (100 × 73 cm).
Centre Georges Pompidou, Paris. Musée National d'Art Moderne/Centre de Création Industrielle.
Donation de M. et Mme. André Lefèvre (Paris)

Henri Matisse
View of Notre Dame (Vue de Notre-Dame). 1914. Oil on canvas, 58 × 37 ⅛" (147.3 × 94.3 cm).
The Museum of Modern Art, New York. Acquired through the Lillie P. Bliss Bequest, and the Henry Ittleson,
A. Conger Goodyear, Mr. and Mrs. Robert Sinclair Funds, and the Anna Erickson Levene Bequest given in
memory of her husband, Dr. Phoebus Aaron Theodor Levene

Matisse
Goldfish and Palette 1914

Picasso
Harlequin 1915

Goldfish appear often enough in Matisse's work to have inspired an art dealer to refer to him as "the master of the goldfish" in a letter to Picasso. He was fascinated by the fishes' flickering movements, and by the way their bodies reflected light. In *Goldfish and Palette* Matisse shows goldfish swimming in a large glass beaker. Omitting details such as eyes, mouths, and fins, he simplifies the fishes' red shapes to smooth ovals that taper into points. Beside the beaker sit a round fruit and a plant whose long leaves arch gracefully. The curving forms of these leaves are echoed by the scrolling black ironwork of the balcony behind them. This type of ironwork, seen often in France, appears in many of Matisse's paintings of his studio and home. The flat blue painted area crossed by the ironwork looks like the sky outside the window, but also seems to enter the room, like light falling across the table on which the beaker stands.

Between this table and the ironwork a mysterious black band runs from top to bottom of the picture. As a dark backdrop to the brighter tableful of objects, the band makes them visually pop forward, so that we question the space of the room—we wonder what is near and what is far, what is in front and what behind. To the right is a white rectangular shape, the artist's palette. Although Matisse does not portray himself in any clear way, he hints at his presence by showing a pale thumb emerging from the hole at the palette's top and a few black lines where his arm would be. All he lets us see of

himself is this ghostlike apparition. The palette hovers above a black diagonal shape, which resonates with the black band behind the still life. The palette also echoes the shape and color of the tabletop. These similarities link the palette to the table; in turn, they also link the artist to the subject he is painting. Matisse invites our eyes to bounce back and forward between what he's doing and what he's seeing.

Goldfish and Palette, like many of Matisse's artworks from this time, looks somber, perhaps in reflection of the mood of the day—namely the beginning of World War I. The flat, simplified shapes and unclear space of this painting also show the influence of Cubism, the art then being developed by Picasso and Georges Braque.

Picasso and Braque were pushing the boundaries of art by inventing new ways of making it. Instead of trying to make the objects in a painting look "real," they played with that idea by fashioning pictures out of actual objects and everyday materials, such as wallpaper and newspaper, that they would glue down onto a surface. The method was called *papier collé*, or collage. Instead of imitating reality in art, Picasso and Braque were incorporating reality in art. It is as if they were saying, "You want real? This is as real as it gets."

In *Guitar* (1913), for example, Picasso combines drawing and collage, applying charcoal, ink, and chalk alongside pasted-down bits of newspaper and other printed pages. He creates the shape of a guitar by setting two pieces of paper at different heights, one white and one printed with a swirling, leafy pattern in brown and beige. The guitar's sound hole

is described by a round fragment of the Spanish-language newspaper *El Diluvio*; two more pieces of the newspaper appear to either side. Picasso made this work during a visit to Céret, a southern French town near the Spanish border. In it he recorded parts of his daily life, including visits to cafés and bars, and the sounds and objects he found there. He also acknowledged his Spanish roots.

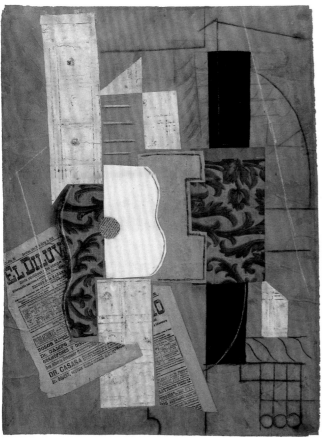

Pablo Picasso. *Guitar*. 1913. Pasted paper, charcoal, ink, and chalk on paper mounted on ragboard, 26⅛ × 19½" (66.4 × 49.6 cm). The Museum of Modern Art, New York. Nelson A. Rockefeller Bequest

Rather like *Guitar*, Picasso's *Harlequin* might at first glance look like a collection of cutout shapes layered on top of each other at odd angles, like a tumbled stack of playing cards. Picasso fools our eyes with an illusion: a painting that looks like a collage. A black, knoblike shape makes up the head and neck of Harlequin, a comic prankster charac-

ter from the centuries-old theater form called the Commedia dell'Arte. His wide white eye stares out at us, his impish grin floats below it, and the diamond pattern of his traditional costume lies askew below that. In fact all of the shapes in the picture are tilted at different angles. To the right, a white-and-beige rectangle suggesting a palette shows a blurry profile of Picasso, who tucked this outline into many paintings, making his presence known. He also often used Harlequin as a stand-in for himself: Harlequin fit his notion of picture-making—the creation of an illusion—as a sort of trickery or magic.

Both *Goldfish and Palette* and *Harlequin* provide glimpses into the two artists' lives, Matisse's painting telling us something about his domestic life, Picasso's showing an idea he had about himself. Artists often revisit ideas and images in different ways, and both of these artworks include recurring themes: goldfish for Matisse, Harlequin for Picasso. Both also include a palette, an essential painters' tool acting as a symbol of the artist and of artmaking.

Goldfish and Palette and *Harlequin* let us glimpse Picasso's and Matisse's acute awareness of each other's work. When Matisse saw *Harlequin* in 1915, he said he believed his *Goldfish and Palette*, which he had painted the previous year, had influenced Picasso. At the same time, *Goldfish and Palette* itself shows the influence of Picasso's Cubism, in the way Matisse layers shapes, paints wide areas of flat color, and experiments with space. Although Picasso and Matisse might have disagreed about who influenced the other more, they both agreed that *Harlequin* was Picasso's best work up to that point. Quite independently of each other, both of them said as much to different people they knew. The same year Picasso painted *Harlequin* he actually wrote to Gertrude Stein that he believed it to be his best painting.

Henri Matisse
Goldfish and Palette (Poissons rouges et palette). 1914. Oil on canvas, 57 ³/₄ × 44 ¹/₄" (146.5 × 112.4 cm).
The Museum of Modern Art, New York. Gift and Bequest of Florene M. Schoenborn and Samuel A. Marx

Pablo Picasso
Harlequin (*Arlequin*). 1915. Oil on canvas, 6'¼" × 41⅜" (183.5 × 105.1 cm).
The Museum of Modern Art, New York. Acquired through the Lillie P. Bliss Bequest

Picasso
Still Life with Compotier 1914–15

Matisse
Still Life after Jan Davidsz. de Heem's "La Desserte" 1915

In *Still Life with Compotier* Picasso continues in the spirit of the trickster Harlequin, playing with and questioning the way we see. Here he shows us a collection of objects spilling over a tabletop, which seems to be tipped up to face us: instead of making the tabletop's left and right edges slant inward to imitate the way the farther side of an object looks smaller to the eye than the nearer one, Picasso makes them parallel. The white *compotier*, or stemmed fruit dish, in the picture's upper center, holding objects such as a pear, bread, and a biscuit, is painted in broken fragments piled together at odd angles. Picasso shows us just enough to figure out what this puzzle-like construction is, although it remains a challenge. Another surprise in the picture is that the left and right sides of the near edge of the tabletop don't meet—they lie at different heights. The overflow of objects and shapes in the middle of the table makes it hard to notice this right away. Similarly, the decorative molding on the wall to the left of the table slips behind the still life arrangement only to reappear on the right higher up. As he did in earlier Cubist works, Picasso is giving us more than one viewpoint within a single painting.

In his Analytic Cubist paintings Picasso had analyzed his subjects by taking them apart. In *Still Life with Compotier* he reassembles them, letting us see their fragments. Picasso's work of this period would later be called Synthetic Cubism—from the idea of synthesis, or putting things together.

Flat, straight-edged areas of speckled paint float on the surface of *Still Life with Compotier* like glued-on sheets of paper. Like the *Harlequin* of 1915, this is a painting that looks like a collage. Some of these areas are semitransparent, letting what lies behind them show through; others look solid, and even cast shadows. These areas contradict any sense that we are looking at objects on a table. The cut-glass tumbler, for example, shows shadows in its decorative scalloping that announce it as a rounded, three-dimensional object, but having created this illusion Picasso denies it by painting a panel of flat pattern over the tumbler's edge. Our eyes flicker back and forth from these obviously flat areas—which remind us that a painting is flat in itself—to the places where Picasso has created the illusion of depth. Meanwhile the objects defy gravity by staying put on the up-tilted tabletop. Picasso is always showing us that he is creating illusions. Where traditionally an artist might have worked to create the feeling that we are looking through a window at something real, Picasso instead reminds us that the image is made up of paint on a flat surface.

Another "trick" in this painting involves the technique of "*faux*" finishing, or fake finishing—a method used by artisans to make one material look like another, usually more expensive one. The left side of Picasso's tabletop bears a pattern of wavy lines that mimics the grain of wood. In the tabletop's right half, though, he abandons this pattern, breaking the illusion. Below the decorative molding, too, thin veins of color make part of the wall look like marble.

Below the *compotier* are two sections of black containing the word "*journal*"—the French word for "newspaper"—split into two. In painting a newspaper's front page, Picasso is showing us one of his

everyday interests. He is also making a joke, a pun: The letters J, O, and U, prominent in the center of the painting, form the beginning of the French word "*jouer*," which means "to play." Picasso is putting us on guard, letting us know that the painting is playing with our eyes.

Henri Matisse. *La Desserte (after Jan Davidsz. de Heem)*. 1893. Oil on canvas, 28¾ × 39⅜" (73 × 100 cm). Musée Matisse, Nice-Cimiez

The subject of Matisse's *Still Life after Jan Davidsz. de Heem's "La Desserte"* is not an actual still life, an arrangement of objects in a studio, but a still life painting by the seventeenth-century Dutch artist Jan Davidsz. de Heem. In 1893, when Matisse was a student, he had painted a copy of this work, *La Desserte*, which he had seen in the Louvre. That copy is fairly true to the original. In making the later version, however, instead of going back to the Louvre, Matisse worked from his earlier copy. Having interpreted another artist's painting over twenty years earlier, he now decided to interpret his own interpretation. It is as if Matisse were saying: Look at the different ways you can paint the same subject. And also: Look how far my painting has come from the way I began.

Matisse's 1915 painting is very large, over eight feet wide. The scale invites us into the scene; it is as if the fractured table in the middle of the picture were set for us. Running down the center of the painting is a black bar, which at the top seems to lie behind the table but then plunges surprisingly into the large bowl of fruit, jumping forward visually. Then it continues down the front of the table, like a shadowy fold in the tablecloth. Throughout the painting, areas of similar color pull our eyes back and forth. Two piece of brilliantly colored red fruit, for example, draw our attention to the center of the picture; the same red appears on the mandolin to the left, and on the curtains that run down the sides.

Matisse was using what he called "the methods of modern construction": the influence of Cubism is visible throughout the painting, with its multiple planes and perspectives. But the subject is traditional. Not only is the still life an age-old theme, but copying great works from the past was a conventional part of an artist's training. Matisse was harnessing the modern and the traditional at the same time.

Picasso's *Still Life with Compotier* and Matisse's *Still Life after Jan Davidsz. de Heem's "La Desserte"* show the artists' work becoming increasingly busy, dense, and filled with contradictions. Some of the objects look flat, while others appear rounded; some seem to lie both in the front of the picture and in the back simultaneously. In Matisse's still life, the objects seem to have a certain weight and a logical placement. In Picasso's painting, however, objects appear to slip off the surface of the table and to float in front of it.

Pablo Picasso
Still Life with Compotier (Nature morte au compotier). 1914–15. Oil on canvas, 25 × 31" (63.5 × 78.7 cm).
Columbus Museum of Art, Ohio. Gift of Ferdinand Howald

Henri Matisse
Still Life after Jan Davidsz. de Heem's "La Desserte" (Nature morte d'après "La Desserte" de Jan Davidsz. de Heem). 1915.
Oil on canvas, 71¼" × 7' 2⅞" (180.9 × 220.8 cm). The Museum of Modern Art, New York.
Gift and Bequest of Florene M. Schoenborn and Samuel A. Marx

Matisse
The Piano Lesson 1916

Picasso
Three Musicians 1921

The Piano Lesson shows Matisse's son Pierre at home playing music. Although Pierre was a teenager when the painting was made, Matisse portrays him as a young boy, his head peering out at the bottom right over a black music stand mounted on a pink piano. The letters written backward across the music stand spell out the name of the piano's maker, Pleyel. Pages of sheet music fan out along the top of the stand. On the piano sit a burned-down candle and a metronome.

Above Pierre's head is a roughly painted figure, a thin, upright woman in a long skirt. She sits stiffly, her hands in her lap, and seems to look down at the boy—but this image actually comes from one of Matisse's earlier works, *Woman on a High Stool (Germaine Raynal)*. Germaine Raynal, the wife of an art critic known for writing on Cubism, had posed for Matisse two years earlier. Another image of a work by Matisse rests at the bottom left, below the window: *Decorative Figure* (1908), a sculpture of a nude woman sitting in a comfortably curved position. The two female figures appear to be opposites: the first, erect and proper; the second, relaxed and at ease. They seem to represent two different aspects of music- or even artmaking: on the one hand discipline and practice, on the other hand beauty and pleasure.

The painting is divided vertically by a blue- and a peach-colored bar—the frame of a French window and perhaps a curtain. Much of the background is a uniform gray, although a large green triangle—evoking grass or foliage—fills part of the window, crossing the balcony ironwork as if seeping into the room. *The Piano Lesson* is mostly made up of large, flat geometric shapes. Triangular shapes, for example, repeat throughout the picture, in the green area, the metronome, and the shadow across Pierre's face.

The objects and figures in *The Piano Lesson* lie at the edges of the painting rather than at the center, encouraging our eyes to move around to see them all. The repetition of similar patterns and shapes also pulls our eyes from place to place; the resemblance between the scrolling ironwork of the balcony and the back of the music stand, for example, connects one side of the picture to the other, and the outdoors to the indoors. Yet the painting does not seem busy—its open expanses create a sense of tranquillity. Made in Issy-les-Moulineaux, Matisse's home just outside Paris, *The Piano Lesson* depicts the artist's everyday surroundings, including his family and his art. With its simple green triangle evoking the outdoors, it demonstrates Matisse's interest in nature, and in nature's connection to art. The painting also asserts his love of music, and music's place in the peace and pleasure of domestic life.

Picasso began to create images of performers and of the theater as early as 1900, when he painted the Commedia dell'Arte character Pierrot for a carnival handbill. Harlequin, another character from the Commedia dell'Arte, began to pop up in his work shortly after, as a stand-in for the artist himself. Picasso's interest in these characters from the Italian theater reached its peak in 1921, with *Three Musicians*.

Three costumed figures face out at us while playing music. At first it is hard to see them individually because they are made up of a patchwork of flat colored shapes, like the layered and overlapping pieces of cut paper in Picasso's collages. In some places, too, large areas of color connect one figure

Henri Matisse. *Woman on a High Stool (Germaine Raynal)*. 1914. Oil on canvas, 57⅞ × 37⅝" (147 × 95.5 cm). The Museum of Modern Art, New York. Gift of Florene M. Schoenborn and Samuel A. Marx

to another, making it difficult to tell them apart. But the figure on the left wears the white costume and pointed hat of Pierrot, and plays a wind instrument. The figure in the middle, wearing a diamond-patterned costume and playing the guitar, is Harlequin. To the right, holding sheet music, is a black-cloaked, ghostlike character who has been

described as a monk. In front of this trio is a table holding a pile of blue, white, and black shapes resembling a still life. Under the table to the left are the dark paws of a large dog, whose body appears in parts among the legs of both people and table. The shadow of his head rears up in the corner of the small, boxlike room.

The costumed figures and the overall darkness in *Three Musicians* link it to one of Picasso's earlier Harlequin works, the *Harlequin* of 1915, although the later picture is more lively. The bright, pointed shapes create a busy rhythm, evoking the sensation of a musical performance. The blocks of color connecting the figures also invite us to think of the way sounds join to make music.

In addition to the Commedia dell'Arte, Picasso was also interested in other forms of theater. On several occasions he designed costumes and decor for dance and theatrical productions, including a production of the Ballets Russes, the Russian dance company run by Sergei Diaghilev. Picasso's wife, Olga Koklova, had been a dancer with the company. Matisse had also designed costumes and sets for a Ballets Russes production in 1919.

Both *The Piano Lesson* and *Three Musicians* are composed of a collection of flat shapes that construct a shallow visual space. Although each artist chose a style that best expressed a particular environment and moment, both artworks show the influence of Cubism. The bright colors and patterns of *Three Musicians* draw us to center stage, where a performance is taking place. Matisse does the opposite in *The Piano Lesson* by placing his subjects around the edges of the picture. Both works are large-scale paintings on the theme of music, but they approach it from different perspectives: Matisse's work is private and meditative, Picasso's is public and dramatic. Each contains themes personal to the artist: for Picasso, the character of Harlequin among friends, and for Matisse, his family life and earlier art.

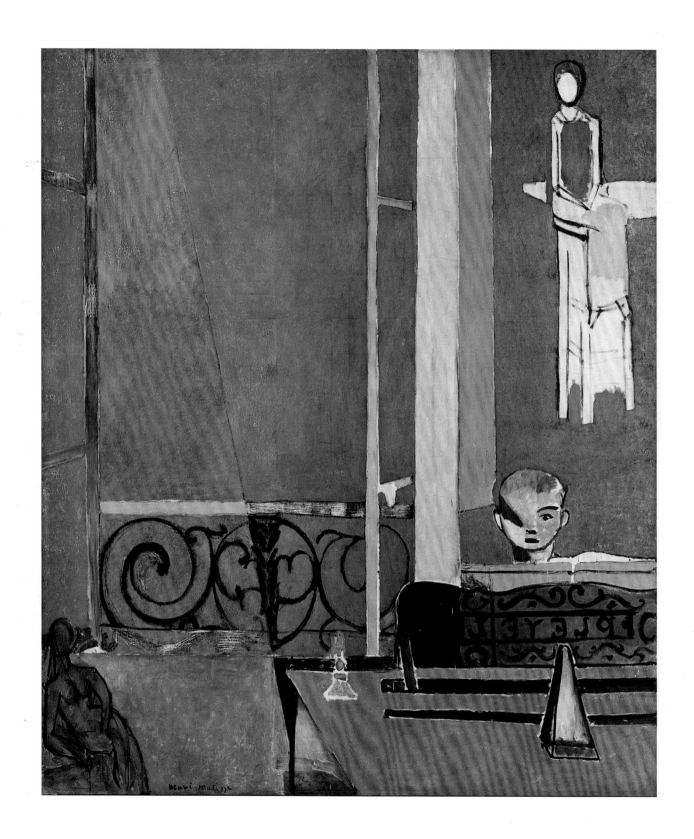

Henri Matisse
The Piano Lesson (*La Leçon de piano*). 1916. Oil on canvas, 8' ½" × 7' 11¾" (245.1 × 212.7 cm).
The Museum of Modern Art, New York. Mrs. Simon Guggenheim Fund

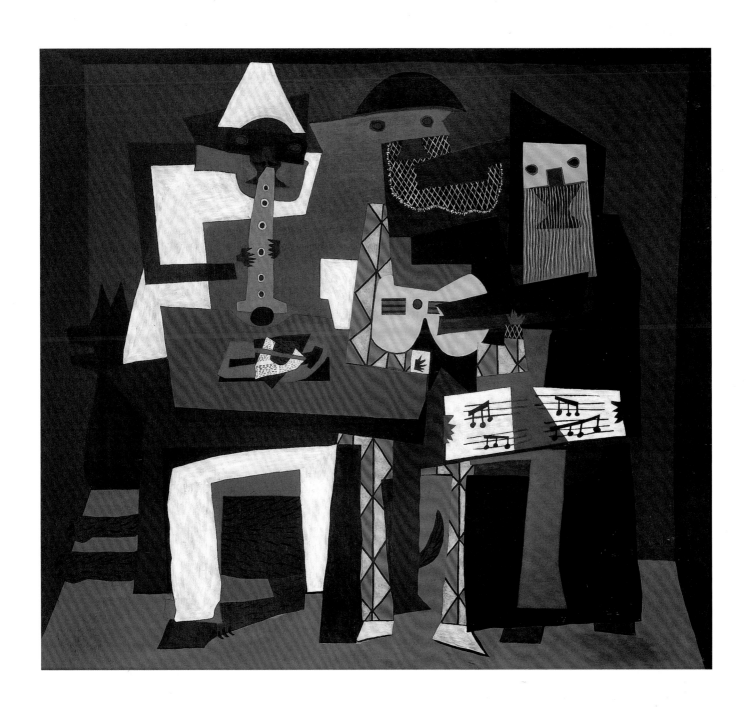

Pablo Picasso
Three Musicians (Trois musiciens). 1921. Oil on canvas, 6'7" × 7' 3¾" (200.7 × 222.9 cm).
The Museum of Modern Art, New York. Mrs. Simon Guggenheim Fund

Picasso
Three Women at the Spring 1921

Matisse
The Back, III, 1916, and *The Back, IV,* 1930

When Picasso painted *Three Musicians*, in the summer of 1921, he was working simultaneously on *Three Women at the Spring*. Both paintings are large-scale works showing the activities of three figures in an undefined space, but they are otherwise dramatically different: the array of flat shapes and colors that makes up *Three Musicians* is entirely unlike the rounded, three-dimensional figures of *Three Women at the Spring*. In fact the two paintings barely seem to have been created by the same artist. Picasso's ability to shift back and forth between styles can be seen as early as 1907, in *Les Demoiselles d'Avignon*, where a variety of approaches to painting can be seen in the same picture. As a modern artist, he felt free to move among different techniques and styles. Picasso once said, "Whenever I had something to say I have said it in the manner in which I have felt it ought to be said. Different motives invariably require different methods of expression."

Picasso often drew from past artistic traditions in his work, and *Three Women at the Spring* was inspired in part by ancient Greek reliefs. The faces of these full-bodied women might have been chiseled from stone; their deep-set eyes, long prominent noses, and small, pursed mouths recall the classical Greek and Roman sculptures that Picasso would have seen in the Louvre museum. He emphasizes this connection by clothing the women in the long, draping gowns often depicted in those ancient artworks. *Three Women at the Spring* is not the first work in which Picasso painted heavy, voluminous figures—he had done so as early as 1906, and would continue to experiment with this way of depicting people throughout his career.

Picasso combines this look toward the past with a modern perspective by making the scene ambiguous or unclear. It is uncertain who these women are, or exactly what their relationship might be, although their nearness to each other and their casual gestures create a sense of familiarity. Their faces, thick limbs, and broad hands and feet are all painted in a sandy-brown color, similar to the background. The lack of detail in the background makes it difficult to determine the setting: we can make out some rocklike forms around the women, but not very clearly. The spring mentioned in the painting's title is hinted at only by the trickle of water that runs into the terra-cotta jug at the center of the picture. By painting these three figures interacting in an environment, Picasso gives us some of the elements necessary for us to piece together a story, but he ultimately confounds our attempts to do so.

During this period both Picasso and Matisse were looking for inspiration to classical reliefs—figures, objects, and scenes carved shallowly from pieces of stone used to decorate the walls of a building or monument. This interest appears clearly in Matisse's sculptural reliefs *The Back, I*, *The Back, II*, *The Back, III*, and *The Back, IV* (1908–30), in each of which the raised figure of a woman stands out as if carved from a flat background. Bit by bit as the series progressed, Matisse dissolved the details of the figure, increasingly abstracting it to its simplest forms.

Matisse began the series by working from a sketch he had made of the back of a woman leaning against a wall. This study clearly defines the naturally curved shape of the woman's head and body, giving weight and definition to her pose. In the very first sculpture of the series, though, *The Back, I* (1908–9), we can see that Matisse has begun to remove natural-looking details in order to focus on the body's basic shapes. By the time he gets to *The Back, III*, he has simplified the figure even further: he exaggerates the length and width of the spine, dividing the right and left sides of the figure into two sections. In *The Back, IV*, the details of the body have been almost fully dissolved. The figure now looks like two columns with a long vertical shape wedged between them. Without having seen *The Back, I, II*, and *III*, we might not know that Matisse was even depicting a human body in this work.

Matisse created *The Back, I* at the same time that he painted *Bathers with a Turtle* and *Dance I*, in 1908–9. *The Back, II* was made in 1913, *The Back, III* in 1916, and it was not until 1930 that Matisse finished the last work in the series. He worked on the Back works through a long span of years. It was Matisse's habit throughout his career to focus on and return to particular themes and interests, constantly reexploring them and probing more deeply into their appearance.

In *Three Woman at the Spring* and in the Back series, Picasso and Matisse depicted female figures in a large, sculptural manner. These monumental figures show the influence of ancient art in stone. They also show the influence of Cézanne, who consistently explored the structures of his subjects, emphasizing the basic shapes from which they were

formed. Both artists were experimenting with different ways of abstracting the figure, but where Matisse chose to record his progression toward ab-

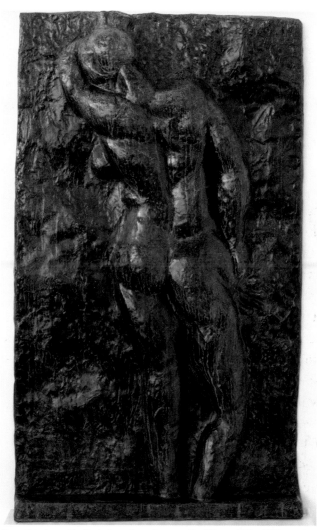

Henri Matisse. *The Back, I.* 1908–9. Bronze, 6' 2⅜" × 44½" × 6½" (188.9 × 113 × 16.5 cm). The Museum of Modern Art, New York. Mrs Simon Guggenheim Fund

straction, investigating a theme and its variations deeply over the course of many years, Picasso was leaping from one style to another with the agility of an acrobat.

Pablo Picasso
Three Women at the Spring (Trois Femmes à la fontaine). 1921. Oil on canvas, 6' 8¼" × 68½" (203.9 × 174 cm).
The Museum of Modern Art, New York. Gift of Mr. and Mrs. Allan D. Emil

Henri Matisse

The Back, III (Nu de dos III). c. 1916–17. Bronze, 6' 2" × 44½" × 6¾" (188 × 113 × 17.1 cm).
The Museum of Modern Art, New York. Mrs. Simon Guggenheim Fund

The Back, IV (Nu de dos IV). 1930. Bronze, 6' 2½" × 44½" × 6½" (189.2 × 113 × 15.9 cm).
The Museum of Modern Art, New York. Mrs. Simon Guggenheim Fund

Matisse
Nasturtiums with "Dance" II 1912

Picasso
The Three Dancers 1925

Matisse called dance "life and rhythm." Among his many depictions of the subject is *Dance I* (1909), which covers much of the background in two views of his studio from 1912, *Nasturtiums with "Dance" I* and *II*. Matisse repeated this image of a ring of dancers in several paintings; as in *Goldfish and Sculpture* (1912) and *The Piano Lesson* (1916), he was depicting his own art within a new work.

At the center of *Nasturtiums with "Dance" II*, a narrow-necked red vase sits on a matching-red stand. Behind it are the gently curving bodies of the dancers in the painting within the painting. The tendrils of a flowering vine emerge from the vase, casting a green shadow along one side of the stand. Just behind the vase, the fingertips of two of the dancers meet, so that the flowers seem to spill from their outstretched hands. The dancers seem to mingle with the flowers. To the lower left, the back of a red chair echoes the diagonal edge where *Dance I* meets the floor. The line created by the two nearest dancers' extended arms also repeats this angle. The chair seat, the floor, and the background of the picture are painted in shades of deep blue. Matisse's use of long lines, similar colors, and this blue creates a calm, meditative environment.

In *Dance I*, Matisse emphasizes the rhythm and movement of dance by eliminating detail, reducing both figures and background to curved lines and areas of bold flat color. Matisse painted this picture to show to the Russian art collector Sergei Shchukin, who had been acquiring the artist's work for years, as a proposal for large-scale paintings on the subjects of music and dance for Shchukin's home in Moscow. The collector agreed, and Matisse then painted for him a new version of *Dance I* (*Dance II*), as well as a companion piece, *Music*. Both paintings were exhibited in Paris's Autumn Salon of 1910. With their unnatural colors and simplified shapes, they were highly controversial, and Shchukin hesitated to buy them. Upon his return to Russia, though, he decided that he wanted them, and wrote to Matisse to say, "I find your panel *The Dance* of such nobility, that I am resolved to . . . hang [it] on my staircase."

Picasso painted *The Three Dancers* in 1925, around the time he and his family visited Monte Carlo to see the Ballets Russes. The painting shows three distorted dancers whose thin, twisting bodies reach to clasp hands. Each figure raises one foot, as though Picasso had captured them in mid-step. The angular figure on the right, made up mainly of elongated brown and white rectangular shapes, partly blends into the background, making it hard to tell if this is a man or a woman. In the center a woman painted in shades of pink, and dramatically outlined in black, stretches her arms upward. The woman on the left is the most distorted of the three: her body bends backward at an improbable angle, and her toothy, masklike face glares out at us. Her pink body is covered with areas of striped pattern, parts of which look transparent.

Behind the dancers is a French window, similar to those depicted in a number of Matisse's paintings, through which we see an iron balcony railing

and bright sky. On either side of the window are the room's moldings and patterned wallpaper. Illogically, many shapes in the painting seem to pop forward visually as if they were in the foreground, instead of receding into the background as we might expect. The result is a sort of disruptive, disjointed movement. Toward the top right a man's head appears in profile, a dark silhouette. Picasso said that this man was Ramón Pichot, a friend who had re-

André Breton, emphatically stated, "We claim him as one of ours," and reproduced *The Three Dancers* along with *Les Demoiselles d'Avignon* in an issue of the publication *La Révolution Surréaliste*.

Nasturtiums with "Dance" II and *The Three Dancers* show Matisse and Picasso addressing dance in different ways. In *Nasturtiums with "Dance" II*, Matisse returns to the subject of dance by depicting part of an earlier artwork in a new painting, reminding us

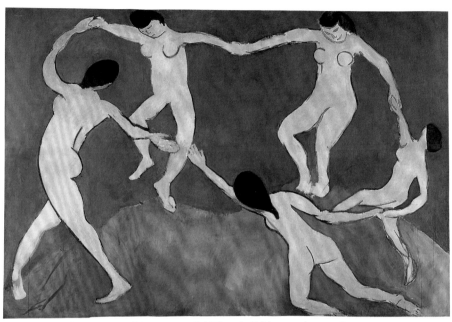

Pablo Picasso. *Four Dancers*. 1925. Pen and ink, 13 ⅞ × 10" (35.3 × 25.5cm). The Museum of Modern Art, New York. Gift of Abby Aldrich Rockefeller

Henri Matisse. *Dance I*. 1909. Oil on canvas, 8' 6½" × 12' 9½" (259.7 × 390.1 cm). The Museum of Modern Art, New York. Gift of Nelson A. Rockefeller in honor of Alfred H. Barr, Jr.

cently died. It is possible that the disturbing figures of *The Three Dancers* were a response to this event.

Some of Picasso's art of this period demonstrates the interests he shared with the Surrealists, a group of artists and writers who were inspired by irrationality, chance, dreams, and the idea of the subconscious. The Surrealists admired Picasso's art, and although Picasso himself would never stick to one style, or follow an artistic movement, they connected his work to their ideas. Their leader,

of the theme's continued presence in his life. In *The Three Dancers* Picasso uses a particular style of painting to convey an aspect of dance. Matisse's painting offers a natural-looking glimpse of his studio and a lyrical image of dance; Picasso shows us a dark, agitated tangle of moving bodies. Matisse, with his figures of dancers and flowers, ties nature and art together; Picasso would later say the opposite: "Nature and art are two different things. Through art we express our conception of what nature is not."

Henri Matisse
Nasturtiums with "Dance" II (Capucines à "La Danse" II). 1912. Oil on canvas, 6' 2¾" × 44⅞" (190 × 114 cm).
The Pushkin State Museum of Fine Arts, Moscow. S. I. Shchukin Collection

Pablo Picasso

The Three Dancers (Les Trois Danseuses (La Danse)). 1925. Oil on canvas, 7' ⅞" × 55 ⅞" (215.3 × 142.2 cm).
Tate. Purchased with a special Grant-in-Aid and the Florence Fox Bequest with assistance from the
Friends of the Tate Gallery and the Contemporary Art Society

Picasso
Painter and Model 1928

Matisse
The Studio, quai Saint-Michel 1916–1917

Simple, flat, geometric shapes and a scaffolding of black lines cover the surface of Picasso's *Painter and Model*. A canvas sits on an easel at the center of the picture. On it we see a profile—Picasso's own. The dots running down the left edge of this canvas are the nails attaching it to its frame. To the right is a black-and-gray oval divided by an upward-pointing arrow on which are painted eyes and a thin, vertical black mouth: the head of the painter working on the canvas. He sits on a yellow upholstered chair. In one hand he holds a palette, the butterfly-shaped brown form with three white dots. With his other hand he draws a profile on the canvas. To the left appears a head with a long, narrow neck—a model posing for Picasso or else one of his sculptures, since it seems to sit on a stand. It is formed out of a column of three eyes, an angular forehead and nose, and a wedge of black hair. In the background is a table with a red tablecloth. Behind that, the horizontal lines of the room's moldings run across the picture. A picture frame hangs on the wall and a pair of windows show the blue sky outside.

The painter looks at his model, but what we see on his canvas is the outline not of the model but of himself—that is, of Picasso. In painting himself on the canvas he seems to be saying that whatever he paints is the reflection of his own mind. The figures of the painter and the model are highly abstracted, Picasso's profile on the canvas much less so. The artist and his model, then, seem less real than what the artist paints.

Some of the objects in *Painter and Model*—the table with its tablecloth and fruit, the picture frame on the wall—had appeared in a slightly earlier work, *The Studio* (1927–28). The room in *Painter and Model*, though, seems busier and more congested than the spacious room in *The Studio*, where the figures and objects are delineated by thin black lines. Both paintings reflect Picasso's interest in the Surrealists, who were exploring the emerging science of psychology. The two paintings can be seen as more than just descriptions of a place; they are also portraits of Picasso's mind, illustrating his reactions to places and people. Picasso once said, "The Surrealists in that way were right. Reality is more than the thing itself. I look always for its super-reality. Reality lies in how you see things."

In *The Studio, quai Saint-Michel* Matisse shows a model lying on a floral-patterned couch. Three faint sketches hang on the wall behind her. In the middle of the room, a board with another sketch attached to it is propped up on a chair, which serves as a makeshift easel. Another chair facing it appears to be where the artist was sitting before he stepped away. To the right, a small table holding a glass on a plate stands by a French window with a brown curtain hanging along one side. Through the window we see the Seine River, the Saint-Michel bridge, and some buildings beyond it. This was the view to the left from Matisse's studio window. The view to the right was the cathedral of Notre Dame, which Matisse depicted in his painting *View of Notre Dame* (1914).

The model in *The Studio, quai Saint-Michel* is a woman named Lorette, who posed often for Matisse around this time. The artwork tells us about Matisse's

experience of artmaking—what it was like for him to paint a model in his studio. As if stepping back to offer us his seat, he shows us remnants of his presence: his model on the bed, his work on a chair, his plate and cup. Through the painting, Matisse

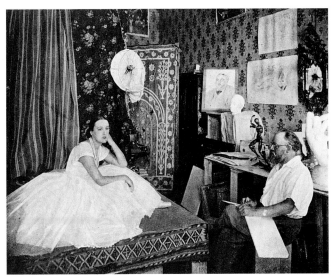

Matisse painting from life, c. 1921. The model is Henriette Darricarrère; she and Matisse are in his studio at 1, place Charles Félix, Nice

offers us a glimpse into a particular moment in his life as an artist.

In 1916, when Matisse began *The Studio, quai Saint-Michel*, he and Picasso were in regular contact. On New Year's Eve of that year, Matisse attended a party that Picasso and several other artists gave for the poet Guillaume Apollinaire, to celebrate the publication of a book of his poetry. A little over a year later, the two artists shared an exhibition in a Paris gallery, for which Apollinaire wrote a catalogue essay on each artist.

The subject of both *The Studio, quai Saint-Michel* and *Painter and Model* is the process of artmaking. Matisse depicts a model posing in his studio, putting us in a position to see what he would see as an artist, and showing us a place that looks as if we could step into it. In *Painter and Model*, on the other hand, Picasso makes a clutter of images and symbols depict his studio, and represent the way he perceives and thinks.

Painter and Model and *The Studio, quai Saint-Michel* explore the different ways in which these two artists saw their studios at specific times in their lives. Matisse almost always began an artwork

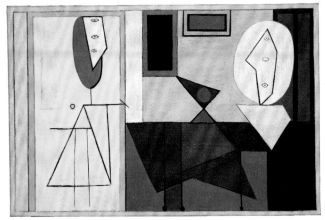

Pablo Picasso. *The Studio.* 1927–28. Oil on canvas, 59" × 7'7" (149.9 × 231.2 cm). The Museum of Modern Art, New York. Gift of Walter P. Chrysler, Jr.

by looking at a model; Picasso rarely did. In *The Studio, quai Saint-Michel*, Matisse reflects upon his actual environment. In *Painter and Model*, Picasso exposes the underpinnings and psychological aspects of artmaking. Both are describing what it means to be an artist.

Pablo Picasso
Painter and Model (Le Peintre et son modèle). 1928. Oil on canvas, 51⅛ × 64⅛" (129.8 × 163 cm).
The Museum of Modern Art, New York. The Sidney and Harriet Janis Collection

Henri Matisse
The Studio, quai Saint-Michel (L'Atelier du quai Saint-Michel). 1916–17. Oil on canvas, 57 ¼ × 46" (147.9 × 116.8 cm).
The Phillips Collection, Washington, D.C.

Matisse
Large Reclining Nude (The Pink Nude) 1935

Picasso
Girl before a Mirror 1932

Matisse's *Large Reclining Nude (The Pink Nude)* depicts a monumental pink female figure lying on her back. She poses casually propped up on her left arm, her left hand hanging down. Her right arm is bent up behind her head, as if to hold it upright. Her head is a small oval, gently framed by her thick arms. Only a few strokes of black delineate her features and hair. The left knee is raised, the right tucked casually downward. The body is simultaneously bulky and graceful, and extends into every corner of the picture. The woman's left hand and the ends of both of her feet disappear beyond the edges of the painting, as if it could barely contain her.

Black lines draw the contours of the woman's body. A blue-and-white checkered ground stretches under and behind her; since all of its lines are parallel, it looks vertical to the eye, and the woman seems to be floating in front of it. At the top center of the painting is a group of round yellow and brown shapes that looks like a vase of flowers. Behind the flowers and above a strip of red wall are the square panes of a window, its grid repeating the geometric pattern of the blue checkerboard.

Matisse's model in this picture was Lydia Delectorskaya, who had been first his studio assistant and then, after 1934, a paid companion to Madame Matisse, who was in poor health. Delectorskaya was the model for several of Matisse's paintings. The artist documented the creation of *Large Reclining Nude (The Pink Nude)* in a series of black and white photographs taken at twenty different stages of the process. In its early stages the painting looked somewhat naturalistic, but as it progressed it became increasingly abstract.

In May of 1935, while Matisse was working on *Large Reclining Nude*, an article he wrote on his Fauvist work of thirty years earlier was published in a London art journal. In the article, titled "On Modernism and Tradition," he said he was revisiting Fauvism in his current works. Indeed, in his paintings of the 1930s, Matisse returned to the bold, expressive color that had crowned him the "King of the Fauves," but he replaced the sketchy brushstrokes of the earlier work with solid blocks of saturated color and pattern.

Picasso's *Girl before a Mirror* portrays a woman stretching out her arms to either side of a long oval mirror. A halo of light surrounds her head. Her face is seen from the front and in profile simultaneously; one side is painted lavender, the other a chalky yellow, with smears of red paint at the cheekbones and lips. Like her face, her long, pear-shaped body is separated into two areas of color: her back is pale green, with a black spine and black horizontal stripes like a long ribcage, while her rounded belly and breasts are the same lavender as her face.

The woman's reflection in the mirror does not exactly match her body. Although the basic shapes are similar, the colors are darker, and the details of the face are more abstract. They are made up of different-colored patches of paint, with a red and a brown dot for eyes and an orange teardrop shape along the cheek. Green and white stripes cover the woman's upper body like a shirt.

Heavy black outlines surround many of the boldly colored shapes in *Girl before a Mirror*, making the painting resemble a stained-glass window. The background behind the woman and her mirror is made up of a diamond pattern—the pattern of the Harlequin costume, which Picasso associated with himself. In choosing this pattern as the backdrop for the scene, Picasso included himself in the painting even though he is physically absent, uniting the painter and his model in an unexpected way. In fact the woman in *Girl before a Mirror* is Marie-Thérèse Walter, a young woman who was involved in a relationship with Picasso for many years.

Picasso portrayed Walter many times, highlighting her blond hair and distinctive profile. In painting her he often used curved and rounded shapes and placed her in intimate settings. As he did through the background pattern in *Girl before a Mirror*, he also often affirmed his relationship with her in these paintings through visual references to himself. In *Bather with Beach Ball*, painted that same year of 1932, Walter wears a purple bathing suit covered with yellow triangles—an abstract version of the Harlequin costume. It was as if Picasso wanted to broadcast the closeness of their connection. He often used purple and yellow in his depictions of her, so that the color combination became almost a sign of her presence, even when the abstraction of the picture made her hard to recognize.

The repeated circles, diamonds, and stripes in *Girl before a Mirror* create a jubilant rhythm throughout the painting. Similarly, the circles, playful pose, and sun-filled background of *Bather with Beach Ball* convey the pleasure of Picasso's relationship with Walter at the time. His work of this period bears similarities to that of Matisse in its decorativeness, luxuriousness, and brightness. Just as Matisse had been influenced by Picasso's Cubism, Picasso was

influenced by Matisse's bold use of flat areas of color and by his work's sensuality.

Both *Large Reclining Nude (The Pink Nude)* and *Girl before a Mirror* focus on a nude female figure simplified into essential shapes. Both figures appear

Pablo Picasso. *Bather with Beach Ball*. 1932. Oil on canvas, 57 5/8 × 45 1/8" (146.2 x 114.6 cm). The Museum of Modern Art, New York. Partial gift of an anonymous donor and promised gift of Jo Carole and Ronald S. Lauder

before similarly patterned backgrounds, and both are painted in areas of bold flat color. Each painting shows a woman at a moment of leisure in an abstractly represented space. The people whom the artists have chosen to paint, however, are quite different: Matisse depicts a model posing for an artist while Picasso depicts his girlfriend. As they often did, the artists reveal different aspects of themselves: Matisse, his life in his studio; Picasso, a personal relationship.

Henri Matisse
Large Reclining Nude (The Pink Nude) (*Grand Nu couché (Nu rose)*). 1935. Oil on canvas, 26 × 36½" (66 × 92.7 cm).
The Baltimore Museum of Art. The Cone Collection, formed by Dr. Claribel Cone and Miss Etta Cone

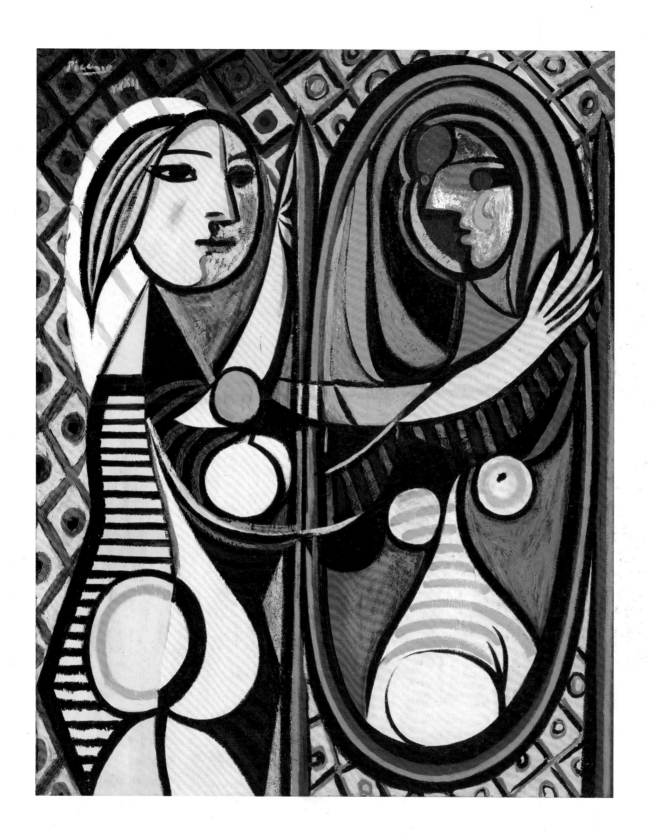

Pablo Picasso
Girl before a Mirror (Jeune Fille devant un miroir). 1932. Oil on canvas, 64 × 51 ¼" (162.3 × 130.2 cm).
The Museum of Modern Art, New York. Gift of Mrs. Simon Guggenheim

Picasso
Head of a Woman (Fernande) 1909

Matisse
Jeannette, III, 1911, *Jeannette, IV,* 1913, and *Jeannette, V,* 1916

Picasso created *Head of a Woman (Fernande)* in Paris during the autumn of 1909. His model was Fernande Olivier, his girlfriend at the time. Picasso began with the basic shape and structure of her head, then transformed the original shapes and proportions, simplifying some and exaggerating others. He divided forms, reduced them to simple geometric shapes, and remodeled them. He stacked shapes at different angles on top of each other to create the craters and bulges we see, making various points of view accumulate within one object. In the words of Picasso's friend the poet Apollinaire, "A man like Picasso studies an object as a surgeon dissects a cadaver."

The fragmentation of *Head of a Woman (Fernande)* shows Analytic Cubism in its sculptural form. In this approach, Picasso and Braque would investigate an object by dissecting its appearance and then rebuilding it to reveal the process of their examination. *Head of a Woman (Fernande)* is less a portrait than an exploration of a structure—the structure of a woman's head and face—and of how that structure could be interpreted. The work is related to several paintings Picasso made of Fernande in the Analytic Cubist style. During this period his painting seems to have informed his sculpture while his sculpture propelled him to think in new ways about his painting. As he said later, "Sculpture is the best comment that a painter can make on painting."

The late spring of 1909 was a productive period in Picasso's work. He and Olivier took a trip to Spain, where he saw his parents and old friends. While he was there he painted *Woman with Pears (Fernande)*, an Analytic Cubist work in which he divided Fernande's head and neck into geometric shapes and flat planes. Her fragmented features are made up of small geometric shapes painted in short, choppy brushstrokes of muted greens, grays, and browns. Behind her to the left, a still life arrangement of pears and peaches lies on the sharp peaks of a folded cloth that spills over the edge of a small crooked table. To the right, a velvety dark-green curtain is draped in angular folds. Although *Woman with Pears (Fernande)* depicts Fernande, it barely resembles her. The painting is less about her and more about Picasso's style, which envelops his subject, whether it is a portrait or a still life.

One by one, Matisse's five Jeannette sculptures transform the head of a young neighbor, Jeanne Vaderin. These increasingly streamlined portrait busts gradually progress toward abstraction. Like the Backs series, the Jeannette works are a permanent record of Matisse's artistic process.

Matisse made both *Jeannette, I* and *Jeannette, II* early in 1910, at his home in Issy-les-Moulineaux. For *Jeannette, I* he worked directly from life, portraying Vaderin's full, rounded face, wide eyes, and pronounced nose. In *Jeannette, II* he removed much of this detail, and worked not from life but from a cast of *Jeannette, I*. Matisse probably thought of the two works as variations on the same subject.

Matisse made *Jeannette, III* between the spring of 1910 and the autumn of 1911, again without having Vaderin pose for him. In this version he generalized the bust into three basic areas: the head and hair, the neck and a section of the chest, and the base below.

Pablo Picasso. *Woman with Pears (Fernande).* 1909. Oil on canvas, 36¼ × 28¾" (92 x 73 cm). The Museum of Modern Art, New York. Florene May Schoenborn Bequest

Vaderin's curls of hair are simplified into large, bulbous shapes. Her eyes are enlarged and exaggerated, and her oval-shaped head tapers at her chin.

Jeannette, IV is more expressive and dramatic than the first three heads. In this version Jeanne's nose and forehead form a single line, a sharp profile that divides her sunken cheeks. Her hair is again mounded into a row of bulging shapes. An image of *Jeannette, IV* appears as a white plaster cast on the right side of Matisse's painting *The Red Studio* (1911).

In 1912, Matisse exhibited his work in the United States for the first time. The show, held in a New York gallery, was strongly criticized, and none of the work was sold. Several of the Jeannette heads were included. One critic said, "The last state is worse than the first." For another, this art was "like the work of a madman."

Matisse made *Jeannette, V*, the final sculpture in the series, in 1916, six years after he began *Jeannette, I. Jeannette, V* is the most dramatically abstract sculpture of the group. Matisse has radically simplified the shapes that make up her hair, inviting us to focus on the narrow forehead and the abstracted features of the face. He flattens the shape of the left eye and models the right so that it protrudes dramatically. A deep crevice runs across the center of the head, exposing the rounded shapes of which it is composed. When Matisse made this work he was exploring aspects of Cubism in paintings such as *Still Life after Jan Davidsz. de Heem's "La Desserte"* (1915) and *The Studio, quai Saint-Michel* (1916–17). The crevice in the head of *Jeannette, V* resembles the triangular wedge that falls over the face of the artist's son Pierre in *The Piano Lesson*, painted the same year. It was not until 1950, over thirty years after Matisse made *Jeannette, V*, that he chose to show all of the Jeannette heads together in a Paris exhibition of his work.

In *Head of a Woman (Fernande)* and the Jeannette series, Picasso and Matisse transformed the appearance of a particular woman by abstracting it. In Picasso's case the woman was a girlfriend, in Matisse's she was a neighbor and acquaintance. Although both artists often altered the appearance of their subjects in surprising ways, here the change is particularly profound. Painters inevitably transform what they depict, since they are creating flat representations of three-dimensional subjects. When artists create sculpture, on the other hand, and particularly portrait busts, they are making three-dimensional depictions of three-dimensional subjects. In this way sculpture can imitate its subjects quite closely—yet these two works thoroughly transform them.

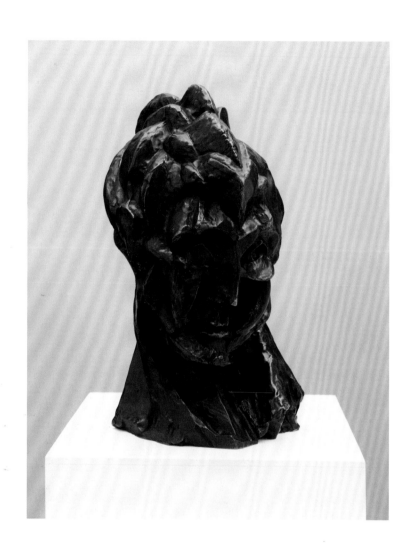

Pablo Picasso
Head of a Woman (Fernande) (Tête de femme (Fernande)). 1909. Bronze, 16 ¼ × 9 ¾ × 10 ½" (41.3 × 24.7 × 26.6 cm).
The Museum of Modern Art, New York. Purchase

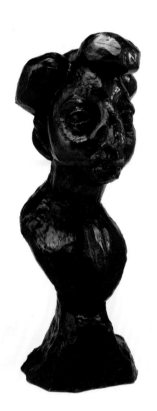 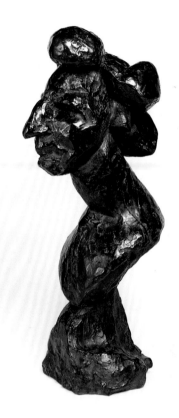 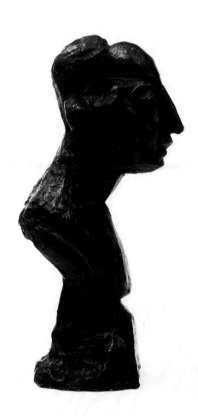

Henri Matisse

Jeannette, III. 1911. Bronze, 23 ¾ × 10 ¼ × 11" (60.3 × 26 × 28 cm). The Museum of Modern Art, New York. Acquired through the Lillie P. Bliss Bequest

Jeannette, IV. 1913. Bronze, 24 ¼ × 10 ¾ × 11 ⅜" (61.5 × 27.4 × 28.7 cm). The Museum of Modern Art, New York. Acquired through the Lillie P. Bliss Bequest

Jeannette, V. 1916. Bronze, 22 ⅞ × 8 ⅜ × 10 ⅝" (58 × 21.3 × 27.1 cm). The Museum of Modern Art, New York. Acquired through the Lillie P. Bliss Bequest

Matisse
Standing Blue Nude 1952

Picasso
Standing Nude (Bather) 1961

tanding Blue Nude may look like a painting of a simplified figure, but it is actually made of individual pieces of paper, cut out and carefully placed. The technique looks simple but Matisse created this work and others like it in several precise steps. He did not use store-bought colored papers; in line with his lifelong passion for color, he preferred to paint large pieces of paper in the specific colors of his choice. This allowed him to pick the exact colors he wanted to use. Although we might not think of *Standing Blue Nude* as a drawing, Matisse referred to the technique of his cutouts as "drawing with scissors." He once said, "Cutting colored papers permits me to draw in color." Drawing was very important to Matisse: years before he made *Standing Blue Nude*, he wrote, "My line drawing is the purest and most direct translation of my emotion. The simplification of the medium allows for that."

Standing Blue Nude is a female figure made of five simple curved shapes painted a luminous blue. Two similarly cut pieces of paper compose the woman's arms, which bend behind her neck as if supporting her head. One piece of paper forms her torso, breasts, and head. Floating below, the thick shapes of her legs stretch evenly downward. None of the five shapes touch. They are glued to a sheet of white paper, which forms the background. The contrast of the blue against the white defines the shapes of the woman's body, although the shapes themselves are flat; they are not painted to suggest the contour and volume we might associate with the human figure. While the areas of blue have some

of the feel of painting, their irregularly cut edges remind us of Matisse in the act of drawing. Matisse's cutouts also remind us of his work as a sculptor: he is carving through a material, in this case paper, eliminating what is unnecessary to leave a form behind.

Picasso's *Standing Nude (Bather)* is a large-scale sculpture made of a piece of sheet metal, cut, bent, and painted white. A woman's figure rises from a flat, rectangular metal stand. All of her angular limbs end in sharp points, and a long sharp fold runs down each of her outstretched arms. The wide forms of her legs are also creased from top to bottom. The directions of these folds and creases alternate from limb to limb, here popping forward,

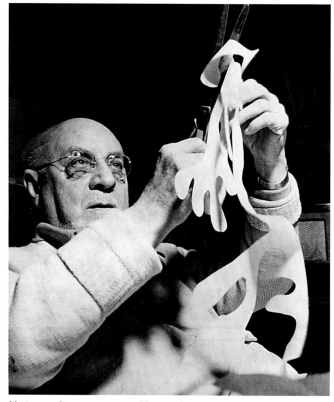

Matisse working on a cutout at Vence, c. late 1940s

there receding back. The woman's breasts and the features of her tiny face are delineated by cuts in the metal. *Standing Nude (Bather)* has a gaunt, lanky look that recalls the twisted bodies Picasso painted in *The Dancers* of 1925. In this sculpture he has harnessed the raw power of the shapes in such earlier, Surrealistic works and refined them into pared-down white geometric planes.

In his Analytic Cubist pictures Picasso had used the entire flat plane of the painting to present a complex sense of volume and three-dimensionality. In *Standing Nude (Bather)*, on the other hand, he flattens sculpture, which is normally three-dimensional, into something approaching a single plane, as if we were seeing it from just one perspective. He once said, "What is it that one looks for in a painting? Depth, a maximum of space. In sculpture, one must try to achieve flatness from any point of the spectators' view."

When Matisse made *Standing Blue Nude* he was in poor health, and was sometimes confined to a wheelchair. Working with assistants in his studio, he would direct them to paint large sheets of paper, which he would shape with his scissors. Then he would direct the assistants to assemble the cutout according to the composition he had designed. When Picasso made *Standing Nude (Bather)* and other works like it, he worked with assistants as well: he made paper and cardboard models of the sculptures he designed, then gave them to artisans who could fabricate them expertly in sheet metal. It was in 1954, the year Matisse died, that Picasso began working with this technique.

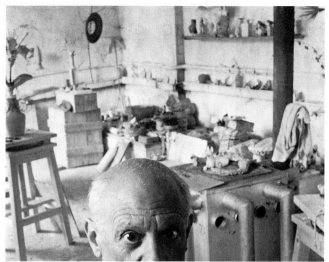

Robert Doisneau. *Picasso in His Sculpture Studio on the rue du Formas, Vallauris.* 1952. Gelatin silver print, 7 1/8 × 9 3/8" (18.1 × 23.7 cm). The Museum of Modern Art, New York. Gift of the photographer

Picasso had worked with cut paper much earlier in his career, using bits of wallpaper, newspaper, and other scraps to make collages. Matisse's cutouts have less to do with the outside world than those works do; the culmination of his artistic career, they testify to his fascination with color. Even at the end of his life, he remained "King of the Fauves."

In *Standing Blue Nude*, Matisse makes a cutout that looks like a painting. In *Standing Nude (Bather)*, Picasso makes a sculpture that is actually a near-flat metal cutout. At an advanced stage in their creative lives, instead of continuing to work in the styles that had brought them fame, Matisse and Picasso were still at the forefront of the avant-garde. Both were enjoying the recognition their earlier work had won for them, yet both remained innovative, continuing to invent new ways of working, pushing the boundaries of every medium.

Henri Matisse

Standing Blue Nude (*Nu bleu debout*). 1952. Gouache on paper, cut and pasted on paper, 45 ½ × 30"
(115.5 × 76.3 cm). Pierre and Maria Gaetana Matisse Foundation Collection

Pablo Picasso
Standing Nude (Bather) (Baigneuse). 1961. Painted sheet metal, 16 ½ × 11 ¾ × 8 ¼" (42 × 30 × 21 cm).
Private collection

Trustees of The Museum of Modern Art